Digital Fashion Print
with Photoshop®
and Illustrator®

Digital
Fashion
Print
with Photoshop®
and Illustrator®

Kevin Tallon

BATSFORD

I would like to dedicate this book to all the people who have helped me along the way, from Binia for her moral support and patience, to Martina Harvey Capdevila for her indispensable help in developing and producing the tutorial chapter, and from my publisher to most of the contributors who have entrusted me with representing in the best possible way their fashion prints.

First published in the United Kingdom in 2011 by
Batsford
10 Southcombe Street
London
W14 0RA

An imprint of Anova Books Company Ltd

ISBN 978-1-84994-004-7

A CIP catalogue for this book is available from the British Library.

20 19 18 17 16 15 14 13 12 11
10 9 8 7 6 5 4 3 2 1

Reproduction by Mission Productions, Hong Kong
Printed and bound by Toppan Leefung Printing Ltd, China

This book can be ordered direct from the publisher at
www.anovabooks.com, or try your local bookshop.

Contents

Preface

My first fashion print

Having written two books about how to work creatively with a computer in the field of fashion design and fashion illustration (**Creative Fashion Design with Illustrator®** and **Digital Fashion Illustration with Photoshop® and Illustrator®**), it seemed only natural to dedicate my third book to fashion print.

Those of you who have read my first book, **Creative Fashion Design with Illustrator®**, might recall that I started my design career with stencil and screen prints on T-shirts back in the pre-digital days when this was the only way to produce a printed T-shirt. I fondly remember doodling some cool artwork during my term-time at high school, then rushing back home to cover the said artwork with that trusty old Amberlith orange film, which had to be painstakingly cut and peeled with a scalpel. Thanks to the help of a local screen printer, who let me use his workshop, I flashed my beloved artwork onto an A4 wooden screen and proudly brought home my first print ready to be applied to stock T-shirts.

The joy of creating, and discovering new tools to work with, be they low- or high-tech, has kept me going ever since and is still central to how I work today. My aim in this book is to transmit that passion and to help readers to reach that magic 'eureka' moment when everything comes together successfully and new skills really make a difference to the experience of designing with a computer.

Inspiration and information

Whether you are a fashion, graphic or textile designer, or are simply interested to know how fashion prints are developed on the computer, this book should, I hope, provide you with plenty of inspiration and the tangible skills required to meet your expectations. **Digital Fashion Print** covers most common print types through a series of practical tutorials and inspirational artworks by a number of well-known contributors. I hope I will convince you, in the course of this book, that I have managed to strike the right balance between design information and visual inspiration.

The meaning of digital

Let's get one thing straight from the outset: the word 'digital', as in the title of the book, refers to a medium, not a print technique. So this book is not simply about printing digitally; it is about working with computers, using Adobe Photoshop and Illustrator, to create prints regardless of how they will be printed.

The digital challenge

Since I first started out 20 years ago, things have changed dramatically with the advent and ubiquitous use of digital equipment. Young designers are now able to create amazing artwork and are free from most of the creative restrictions known to their predecessors. But with so much choice and the potential to get lost in a 'digital maze', it can also be daunting to work efficiently on a digital platform. Designers have to guard against being distracted by the plethora of available digital tools and must always remain focused on the print that will eventually adorn a garment. Digital tools are there only to facilitate the development process. As a fashion print designer you should always think laterally and engage positively with the digital medium, but never forget to put creativity at the centre of your work.

Innovative teaching methodology

If I have one major aim, it is always to innovate and evolve my teaching methodology, and to share this with my students and readers. Since I wrote my last book, **Digital Fashion Illustration with Photoshop® and Illustrator®**, I have gained an extra couple of years of hands-on teaching of both professionals and students. I have tested various tutorials on my student cohorts or clients, seeking by trial and error to understand which teaching methodologies work best for advanced students and beginners alike. As a result, you will be able to work with tutorials that have been designed with all these latest methodologies embedded.

I hope this book will convey my passion for creating fashion prints in the digital medium. Lastly, remember to retain an element of fun, curiosity and deference, and always focus on creativity above technology.

Kevin Tallon

Fashion print for the digital age: a point of view

Fashion print, historically, has always been integral to fashion, but over time it has become a more prominent and relevant part of the fashion language. Not surprisingly, it is technology that has enabled the gradual development and ubiquity of print applied to textile.

Early records (c. 300 AD) point to China and Egypt as the first cultures to develop print on textile by applying carved wood blocks covered with dye onto fabric. In Europe printed textiles only really took off in the 17th century. Countries such as Germany, Austria and Switzerland were known for their masterly skill in calico printing. France, especially, was renowned for its master craftsmen operating from Jouy (from where *toile de Jouy* originated) and Rouens. Even then technology, with the advent of washable inks, was an important factor in making printed textiles more accessible.

Textile printing was not left unaffected by the Industrial Revolution and in 1783 a Scotsman, Thomas Bell, patented his invention of the roller printer, which is still, albeit in a modern version, largely used today for most four- to 12-colour all-over prints. This machine allowed mass production and made wood-block printing an obsolete and archaic technology. The roller printer made it much easier to print seamlessly on fabric roll, and as a result all-over fashion prints became more affordable and accessible. By the mid-19th century a roller printer could produce up to 10,000 m (10,936 yd) of fabric per day.

A step closer towards a fully democratic use of textile print tools was taken only in the early 20th century, when in 1907 an Englishman named Samuel Simon patented screen printing. Although screen printing had first been invented in China more than 700 years earlier, advances in technology, and especially chemistry with the use of chromates, glues and gelatine compounds, allowed screen printing to be more readily available and practical. Despite this, however, screen printing remained the preserve of a few and was mainly used for luxury fabrics such as silk.

Nevertheless, the relatively simple technology inherent in screen printing sowed the seed of the first truly user-friendly and non-professional print technique used by artists, activists and other luminaries. Screen printing became the most DIY-democratic way to print artwork, flyers and posters.

This DIY approach had limitations, however, with the quality and precision of each print being at best haphazard and hostage to unreliable set-ups. Seeking a way to better the DIY state of play, American entrepreneur Michael Vasilantone invented the rotary multicolour garment screen-printing machine in the late 1960s. This new machine, which made printing garments with multiple colours much easier and more accurate, was highly influential in driving huge growth in affordable mass-printed T-shirts.

Parallel to this, an important sartorial-related socio-cultural shift was taking place. In the early 1950s T-shirts were still worn strictly as men's underwear, as they were originally designed to be. But defiant young people, such as members of motorcycle gangs in California, made a statement by wearing T-shirts as outerwear (probably inspired by American troops donning T-shirts in hot tropical climates in the later part of the Second World War).

The evolution of print technology and the socio-cultural change in sartorial attitudes spawned the printed T-shirt. It is difficult to ascertain who printed the first ever T-shirt and what the design was. Some claim that it featured a print depicting Elvis Presley with his guitar in the late 1950s, but a more reliable source points to Miami, Florida, where a local company called Tropix Togs printed T-shirts with either resort names or cartoon characters such as Mickey Mouse.

The second half of the 20th century saw a huge expansion in the availability of printed textiles. Every decade had its seminal print style and a socio-cultural movement associated with it – for example, tie-dye and the hippies. This expansion rode on the back of the technological innovations so prevalent in the later part of the 20th century. Technology really made it possible for most dedicated textile print designers to have a go at expressing themselves with small-quantity runs at relatively affordable prices.

One of the most important innovations, despite not being invented specifically for textile print, was the personal computer. From its modest start the personal computer has increased in power and performance dramatically in less than 25 years, and has now become an indispensable tool. Initially able to produce only simple graphics and print them out on transparent film for screen printing, a computer can now fully manage print processes from beginning to end, completely taking over our day-to-day working practices.

Likewise, the humble inkjet printer made its debut in the early 1980s, and although originally invented for paper printing, it was set to become the next big thing in textile printing. However, many issues specific to printing on textiles had to be tackled: unlike paper, fabric stretches, breathes, has a textured surface, is highly porous and therefore absorbs more ink, and it needs to be washed. There are also many different types of fabric, both natural and synthetic, each with their own characteristics and requirements.

Yet today, digital textile print has managed to iron out most of these problems and has become one of the most exciting technologies for the 21st century, with still so much scope for innovation and expansion. It is not so much the inkjet technology that is revolutionary; it is that artworks can be printed directly from the computer onto textile or garment without the need for a transitional stage. This is the single most important attribute of digital textile print and it is quite unlike anything before it: no more need to convert a design onto a screen or roller, or even a wood block; no more limitations of colour or minimum quantities. At last a truly democratic and purely artistic way of printing has arrived. Just as with the advent of screen printing a hundred years ago, technology has enabled us yet again to be more creative and explore new printing possibilities that not so long ago were not even dreamed of. I am confident that the 21st century will bring us many more innovations in the field of printing that will further enhance our experiences with textile print creation.

Screen printing wash room; Screen printing frames; Colour lab dips.

Before starting

How to get what you want from this book

This book in no way pretends to cover every single aspect of textile prints. Fashion and textile designers tend to require very specific print styles and techniques that follow the current trends, so today's hot print style can very easily become tomorrow's unwanted item in a charity shop – although, of course, the natural life-cycles of fashion mean that designs often resurface a decade later! As a designer, knowing what kind of print you want to create and develop is the first step as you begin your journey through this book.

Digital Fashion Print is intended to help the designer who can think laterally; it has a non-linear and modular structure. Each chapter focuses on a key print style, but the book's approach is flexible and allows readers to switch swiftly from one chapter to another if they wish. I have tried to create a book that is simple to use and invites easy browsing for those who need a quick answer to a problem, be it technical or creative. I hope readers will be able to mix and match different tutorials to create their own print variations.

All the tutorials in the book have been developed with either Adobe Photoshop or Illustrator; both these applications are considered design standards and are the most commonly used in the creative field. The focus of each tutorial is geared specifically to the needs of the textile designer and covers purely print-related topics in either Photoshop or Illustrator, ignoring any irrelevant skills or obscure subjects. I am always conscious of the fact that designers want to get on with the job of creating fabulous prints and tend to be put off by lengthy and detailed explanations of how to achieve this or that skill.

Thin slicing

Let's face it: no one can claim to know an application, be it Photoshop or Illustrator, from beginning to end. The depth and scope of these applications are truly limitless. This book, like my other titles (and in no small measure evolving from them), focuses only on what is most pertinent for textile designers. With the added experience gained from feedback on my previous books, I have gone through an even tougher slimming-down process to get to the core information that is really relevant to readers. This thin-slicing approach is highly appropriate for our 21st-century world, in which no one has any time for real in-depth knowledge. So whatever skills you seek here, you will find short, sharp and to-the-point answers.

Love thy computer

Unless you are from a generation where personal computers did not exist in your student years, you have no excuses for blaming it on the machine. Today, for most of us, a computer is as ubiquitous as pen and paper, and yet quite often it is ill-used. Everybody wants the latest laptop to show off, but many don't have the faintest idea what it is capable of doing – so I am inviting you to love and understand your machine a bit more! I am not asking you to become a fully fledged geek, but simply to acknowledge that by understanding your computer and its applications better you will get so much more out of it. This can be as simple as reading the online manual or asking for advice on what kind of machine you should purchase for your needs.

Drill your skills

I have seen many students and professionals struggle to master design skills on the computer. Sometimes this could be attributed to the smallest stumbling block; on other occasions the general approach to learning a skill was to blame. The key to success in learning new skills and, most importantly, retaining them for use when you really need them is simple: drill. If a given skill is proving difficult, break it down into small chunks. If you stumble at a particular point in the process, observe and take good note of exactly where you stumble; focus on that difficult point, think why you are not succeeding and act laterally. Be positive and do not fear the machine; it won't bite back. Whatever happens, the most important thing is to have fun and let the creativity flow from your mind to the screen.

Creativity first

But enough with all this praise of the machine! The most important element of your work is you, the designer, the artist. When you are developing a print, think and act as if your life depended on it. Look around, with a critical but not cynical eye, and observe what other designers are coming up with. Be inspired and stimulated to create your own version at this particular point in time – enjoy the Zeitgeist!

The tutorials in this book have been developed using an Apple Mac computer, so all the screen grabs depict an Apple Mac interface of either Adobe Photoshop or Illustrator. But PC users can rest assured; any instructions in the tutorials that are different on a PC are clearly highlighted as such. You can be confident that you will be able to follow all the tutorials if you are using a PC.

Adobe CS5

Every tutorial in this book has been conceived with either Adobe Photoshop or Illustrator CS5. This latest version of the Adobe Creative Suite (CS) was released in the spring of 2010. Users of earlier versions should have no problems following the tutorials, although I recommend having at least Photoshop and Illustrator CS3, which introduced the Quick Selection tool, Refine Edge and better print control for Photoshop, and Isolation mode, Eraser tool and Live Colour for Illustrator. All these new features really help to create better compositions and have become indispensable for any serious textile designer who can use them well. Where a tutorial contains features relevant to CS5 only, these will be clearly indicated.

 Adobe Illustrator CS5 icon

 Adobe Photoshop CS5 icon

Keyboard shortcuts

I am always surprised when instructing students to use the Shift and Alt keys for a given task – they respond by looking at their keyboards in wonder, trying to locate those elusive keys. So to clarify this once and for all, here is a foolproof table and images of both the Mac and PC keyboards. These keys are important since they are used constantly and should be instinctively pressed when needed, to ensure good workflow. As those who have worked on both Mac and PC should know, the main difference between the two keyboard interfaces is the use of the modifier keys: Mac uses the Command key and PC the Control key. So, to print a file, a Mac user will press Command + P and a PC user Control + P. This book will always feature the Mac and PC keyboard shortcuts in shorthand form, as shown here:

Symbols and abbreviations	Equivalent
Ctrl	Control key
⌘ or ⌘ (Mac only)	Command key
Alt or ⌥	Alt Key
⇧	Shift key

Apple Mac keyboard

PC keyboard

Quick tips

Also found throughout the tutorials chapter (page 120) are some 'Quick tips', which give expert advice on specific issues and reveal some 'tricks of the trade'. Quick tips usually help readers to understand a given tutorial in more depth or highlight a particularly difficult aspect of a tutorial. They are 'life-savers', based on an insider's knowledge of skills and techniques that reflects years of experience working on fashion prints digitally. A good tip can dramatically increase your productivity from low to high and enhance your experience when designing on the computer.

Digital tools

Assuming that you are a student, freelancer or someone wanting to start a textile print studio, here is a shopping list for a decent set-up to get you started in designing textile prints digitally. One important thing to consider is that although computers are getting faster and smarter, so too are the applications running on these machines: for example, Adobe CS5 takes a lot of disk space, and requires plenty of RAM and a decent graphics card to run smoothly.

Computer: if you are going to work on high-resolution digital prints and with Adobe CS5, you will need a fairly recent Mac or PC with at least 4GB of RAM and plenty of hard-drive space (250GB). Although everybody loves a laptop, desktop computers are much better value for money, with higher specs and larger screen sizes than laptops.

Scanner: although most designers hate to admit it while taking pictures on their latest smartphones, flatbed scanners are still very useful for transferring a hand-made print into Photoshop. If you can afford it, go for an A3 scanner; if not, a decent mid-range A4 one should suffice.

Graphics tablet: if your budget allows, it is worth investing in a bigger graphics tablet; aim for one larger than A5 format. Using a tablet will enhance your working experience, and more flexible and responsive tablets will help you to achieve better print designs.

Digital camera: don't be seduced by the number of megapixels; what you need are good lenses and a CCD chip, and if you can afford a good SLR, even better. But think about what you need your camera for; there is no need for a big SLR if you just want to take snaps for research.

Printer: even if your prints will not end up on paper, you should still invest in a good A3 inkjet printer. Since digital print technology on textile is based on inkjet printing, there is nothing better than a quality inkjet printer for previewing your artwork.

Storage: please back up your files. We are all falsely reassured that everything is fine, that our trusted computer will never crash, be stolen or burnt, but it happens more often than we realize, so be prepared for Plan B and back up those precious prints on an external hard drive. Online storage is also a popular solution since files can be accessed remotely anywhere in the world.

Textile printing workflow

Every print development workflow has a number of key stages, from sketching an initial print idea to having it mass-printed on textile. These key stages are explained below. Understanding workflow is important to ensure good print development. Different printing methods require different actions to be taken, and not all of them will require all the steps outlined here. The tutorials chapter follows chronologically the workflow shown below.

Key stages

Briefing: at this stage the designer is briefed on the requested print. It is important to ascertain the size of print required, the type of fabric on which it will appear, and the kind of look and finish that is expected. All these factors will have an influence on development.

Application: following on from the briefing, the designer should know exactly how the printed textile will be used as a garment. As well as establishing the type of fabric, it is important to know the type and purpose of the garment – for example, will the fabric be subject to considerable stress or not, and will the garment have other embellishments, multiple washes, etc.?

Printing method: for this crucial stage you must know and be able to advise on exactly the kind of print method you believe is best for a particular print. Make sure that the client/line manager fully understands the price points, the minimum quantities, the ease of manufacturing, and the quality and durability of the given print process. Screen printing is best for placement prints; digital printing is best for photo-realistic prints, but can be pricey; roller printing is best for all-over prints, but requires large minimum quantities.

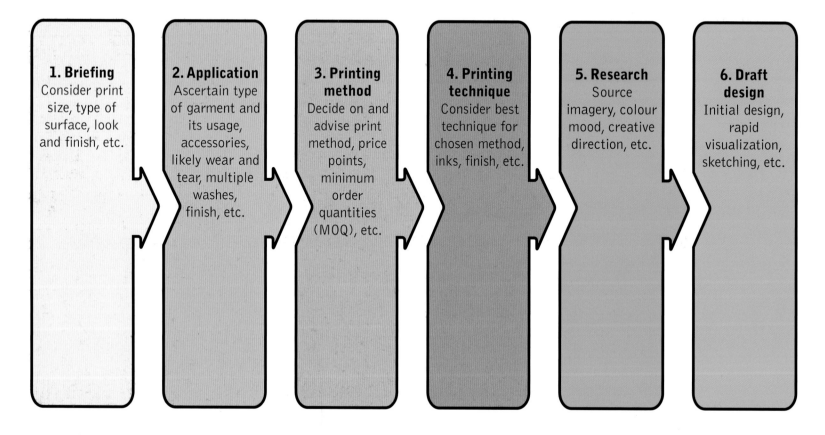

1. Briefing
Consider print size, type of surface, look and finish, etc.

2. Application
Ascertain type of garment and its usage, accessories, likely wear and tear, multiple washes, finish, etc.

3. Printing method
Decide on and advise print method, price points, minimum order quantities (MOQ), etc.

4. Printing technique
Consider best technique for chosen method, inks, finish, etc.

5. Research
Source imagery, colour mood, creative direction, etc.

6. Draft design
Initial design, rapid visualization, sketching, etc.

Printing technique: each printing method has a set of techniques with widely differing outcomes. Again, it is important to consider which technique is the best one to use for a chosen method. Some techniques use different kinds of inks; others require different approaches to the print development.

Research: source the imagery that will inspire the development of your prints, from a tracing template to source images for digital compositions.

Draft design: try rapid visualizations of the print to be developed to get a feel for the way it might look. Avoid spending too much time on minor details at this stage.

Design development: once a draft is good enough to develop, start the process of producing the print. Various issues must be considered, depending on the method and technique to be used.

Mock-up: printing your artwork on paper at actual size and placing this on the garment can really help to validate the print's proportions before you commit to a print strike.

Technical packs: the print must be displayed on a technical sheet with all the relevant information for the print house. The print technique, colour usage, finishes, etc., must all be clearly indicated.

Print strike: the print house should always supply a first test print so that the quality and colour accuracy can be checked. What looked great on paper at mock-up stage might not work as well on textile.

Adjustment: retouching the print, based on the print strike results, might be needed. Sometimes this can be very swift, sometimes very long-winded; it will depend on the complexity of the print.

Bulk printing: finally, the print is mass-produced. Further adjustments may be needed, but these are usually done by the print house.

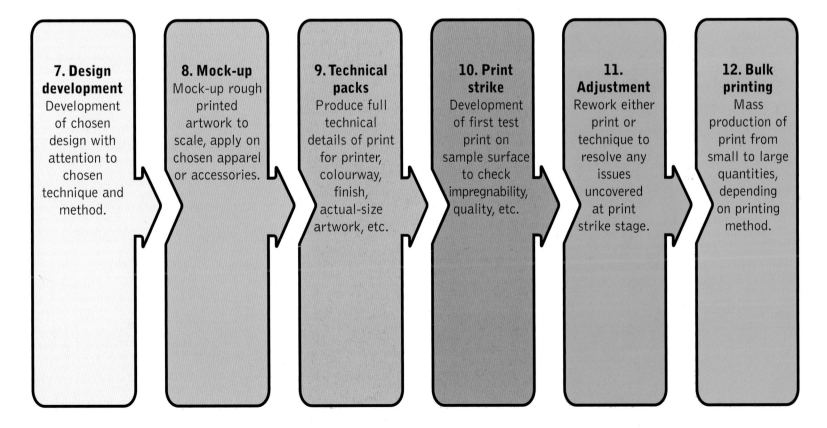

7. Design development
Development of chosen design with attention to chosen technique and method.

8. Mock-up
Mock-up rough printed artwork to scale, apply on chosen apparel or accessories.

9. Technical packs
Produce full technical details of print for printer, colourway, finish, actual-size artwork, etc.

10. Print strike
Development of first test print on sample surface to check impregnability, quality, etc.

11. Adjustment
Rework either print or technique to resolve any issues uncovered at print strike stage.

12. Bulk printing
Mass production of print from small to large quantities, depending on printing method.

Adobe Photoshop CS5

Overview

Most Creative Suite (CS) applications, such as Photoshop CS5, have become so vast that it is easy to get lost in them. It is much smarter to focus on just the elements that are relevant for your purpose. So here is some information about the basic principles, features and tools that should be useful to digital fashion print designers.

Photoshop is bitmap image-editing software; any image opened in Photoshop is made of pixels. The more pixels, the better the image quality. The size of any image in Photoshop is described in terms of its document size (the physical size) and its pixel dimension (the number of pixels within the document size). Two versions of the same image can have the same physical size but very different pixel dimensions.

The Image Size window describes how many pixels are contained

within a given image. It is very important, especially when planning to print digitally, to be aware of the physical and pixel dimension of a developed artwork to avoid any unpleasant surprises later.

Photoshop's Image Size dialog box

Both images shown below are of the same physical size, but at different resolutions.

Image at 72dpi (142 x 170 pixels), which is blurred and pixelated due to its low pixel count

Image at 300dpi (591 x 885 pixels), with much clearer details due to the higher pixel count

The interface

Since the introduction of its CS3 version, Photoshop's User Interface (UI) has been dramatically updated. Its zooming and panning is now much faster, and in close-up view the Pixel Grid helps to maintain clarity between each pixel as they are slightly separated from one another. Please note that due to this ultra-fast Graphical User Interface (GUI) you need plenty of RAM and a good graphics card on your computer to avoid sluggish performance. Photoshop CS5 also has a new workspace management option with which you can set up the UI palettes as you want them on your workspace for specific tasks (painting, retouching, etc.). You can switch from one workspace to another using the collapsible Workspace Switcher.

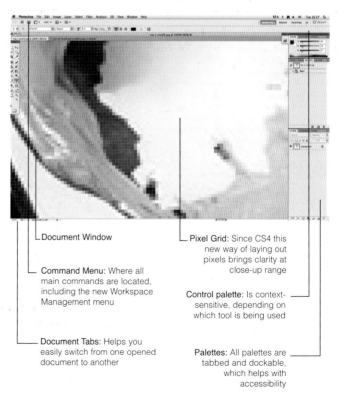

Document Window

Command Menu: Where all main commands are located, including the new Workspace Management menu

Document Tabs: Helps you easily switch from one opened document to another

Pixel Grid: Since CS4 this new way of laying out pixels brings clarity at close-up range

Control palette: Is context-sensitive, depending on which tool is being used

Palettes: All palettes are tabbed and dockable, which helps with accessibility

New features

Photoshop CS5 has many new features, but only a few are really relevant to print design. When working for print most designers will either 'comp' their artwork (select, cut out and alter elements, then put them together) or paint from scratch using digital brushes. Here are four new features that help with compositing and digital painting.

Refine Edge

The best way to select objects in Photoshop CS5 is first to use the Quick Selection tool and then the Refine Edge dialog box. Although Refine Edge has been around since CS3, it has come of age in CS5 with the new Edge Detection option, which can pretty much deal with any tricky edge (for example, hair, feather, soft edge, etc.).

Puppet Warp

A new addition to CS5 is the Puppet Warp function (found in the Edit menu), which enables accurate distortion of image selections or objects. You can distort selected image elements by adding Pins or control points at key intersections (for example, the elbow and

shoulder points on a model's arm); the Pins act as articulated joints. Any image with the Puppet Warp function will have a 3-D-like mesh added to it, which acts as a guide for warp and distortion.

Bristle Brushes

The Bristle Brush is a new brush type that is found in the Brushes palette. It comes with many preset brush tips. Unlike previous brushes, Bristle Brushes can be customized to resemble 'real' brushes. You can, for example, choose how many bristles your brush should have, and how long, thick and soft they should be.

Mixer Brush tool

This new Brush tool allows you to blend or mix different colours together, giving a realistic look and feel. Mixer Brush can also blend a solid colour with an underlying image, so, for example, you can trace-paint a flower directly on top of a flower picture.

A picture before using the Mixer Brush tool

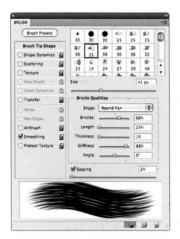

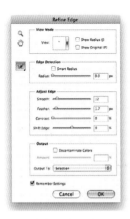

The new Refine Edge dialog box with the Edge Detection option

Vintage scissors before and after the Puppet Warp treatment – note the mesh and the Pins

The Brushes palette, including ten base Bristle Brush shapes

Floating Brush preview window

Mixer Brush tool

The same image after painting with the Mixer Brush tool

Adobe Illustrator CS5

Overview

For many years Illustrator, compared to Photoshop, has been the underdog when it comes to fashion print. This is due in part to the fact that most designers in the past would compose their prints with real media and scan them in Photoshop to clean up their artwork. Quietly but surely, however, with each version Illustrator has been building an impressive arsenal of tools that are now challenging Photoshop as the *de facto* fashion print application.

Illustrator is vector-based drawing software. Any object drawn with a vector tool can easily be scaled up or down without any loss of quality, unlike bitmap images. Add to this the fact that Illustrator allows any vector object to be fully editable, and that it handles bitmap and vector graphics effortlessly, and it becomes clearer why Illustrator is so enticing. More specifically, for fashion print designers, Illustrator has a very powerful Pattern Swatch function, which delivers slick and seamless all-over prints when used properly.

A vector object drawn in Illustrator

The same object scaled up without any loss of quality

A segment line with a Zig Zag effect applied

A bitmap image with vector graphics

Tile design for a pattern swatch

The same pattern swatch applied onto an object

The interface

The main new interface feature developed under CS4 was Multiple Artboards, which allowed you to create different-sized artboards in one document. Illustrator CS5 has continued to develop and enhance Multiple Artboards with new features that enable you to change the artboard running order via the new Artboard palette, paste in place objects on all artboards, and save individual artboards as separate Illustrator files. As illustrated below, Multiple Artboards can be very useful to a fashion print designer; for example, they enable you to have one artboard for sketching the print, a second one for developing the print tile, and a third one for testing out the repeat at 1:1 scale.

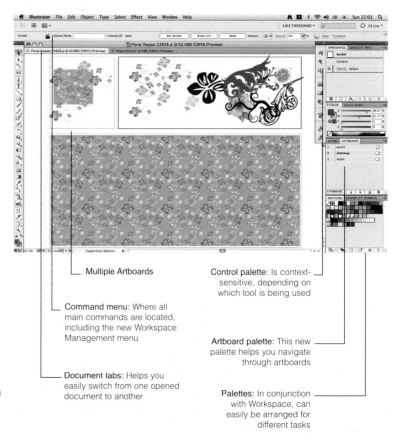

Multiple Artboards

Command menu: Where all main commands are located, including the new Workspace Management menu

Document tabs: Helps you easily switch from one opened document to another

Control palette: Is context-sensitive, depending on which tool is being used

Artboard palette: This new palette helps you navigate through artboards

Palettes: In conjunction with Workspace, can easily be arranged for different tasks

New features

As Illustrator is now in its 15th incarnation, only a few completely new features, such as Perspective Drawing, are available in CS5; most additions are enhancements from previous versions. Nevertheless, this does not mean to say that Illustrator CS5 is not worth the upgrade. Beautiful Strokes, Bristle Brush, and Draw Inside and Draw Behind are well worth the investment, especially if you are considering leapfrogging from CS3. So let's have a look at how these new features can be useful for digital fashion print designers.

Beautiful Strokes

Under this annoying title lie some really great new features for dashed strokes, brushes, and any object with a stroke. Using the new Width tool, any segment with a stroke colour can have a different width applied to it. Pre-defined stroke styles can also be added. On the brush side, the new Stretch Control option defines how Art and Pattern brushes scale along a path.

Bristle Brush

This new brush enables designers to paint with the appearance of a real bristle brush; the painting style will be fluid and life-like. As with Photoshop CS5, you will get much better results if you use a graphics tablet, since the Bristle Brush tracks all movement, orientation and pressure of the stylus. Illustrator's Bristle Brushes are not as life-like as those in Photoshop, but this is easily counterbalanced by the vector path editability. Users can easily create and customize their own Bristle Brush by using the New Brush option in the Brushes panel.

Draw Inside and Draw Behind modes

These two new drawing modes are great additions to Illustrator and will help with workflow and productivity. The two modes are activated by clicking onto either the Draw Inside or Draw Behind mode found at the bottom of the toolbox. Draw Behind enables you to draw behind all objects present on the artboard, which is very useful for quickly painting a background. With Draw Inside you can select a shape and paint over it without worrying about the overspill, which is automatically clipped away.

The Width tool

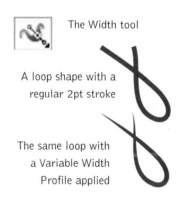

A loop shape with a regular 2pt stroke

The same loop with a Variable Width Profile applied

An Art brush without Stretch Control applied

The same Art brush with Stretch Control applied

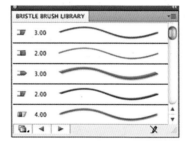

The Bristle Brush Library

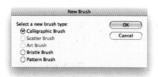

Creating a new Bristle Brush

A heart shape drawn with Bristle Brush

A star with a regular 2pt stroke

The same star reworked with the Width tool

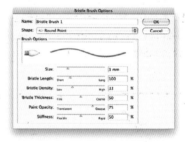

Customizing a new Bristle Brush

A vector rose with its outline selected for Draw Inside mode

The rose is painted over with a Bristle Brush

The Draw Inside mode automatically clips the overspill

Chapter 1
Made by hands

Some of you reading this book right now might have been born recently enough not to have known a world without computer-aided design. If this is the case, you might balk at the idea that anything could be created without a computer – and I must admit that I myself am a big proponent of all things digital.

Nevertheless, using natural media and hand work – that is, working without a digital tool – is still totally relevant today. There is nothing better than getting your hands dirty and creating something with real tools and media, working emotionally rather than empirically, which is usually the case when working on the computer. You can try as hard as you want, but most digital applications' attempts to mimic natural media are usually pretty lame. They always remind me of amateur copy artists who spend countless hours slavishly copying classic paintings, ending up most of the time with only half-decent reproductions.

We could argue about the pros and cons of digital versus natural media until the cows come home, so why not rather embrace both and recognize what each does best? Quite simply, the digital medium is good at doing all things that require precision and is great for quick experimentation and editing (and you don't need to wash the brushes or sharpen the pencils!). Natural media are, of course, very good at generating the artwork from scratch; at translating our creative emotions into beautiful artworks.

In this first chapter we look at prints that have mainly been done by hand with natural media, and then digitally imported and adjusted in Photoshop. Most adjustment techniques are showcased in the early part of the tutorials chapter (Chapter 7). The skills needed to 'digitize' these kinds of artworks are generally centred on importing images (scanning and camera import issues), adjusting images (balance, levels and curves), and knowing how to retouch images (Eraser tool, Clone Stamp tool, Spot Healing Brush tool, etc.). You might also refer to the selection tutorials (Tutorials 3 and 4) if you are using several scanned or digitally sourced images to compose your prints. So, have a look, get inspired, and try things out.

KELLY ALLEN
The Royal Albert Memorial
Engineered digital print on dress. Hand-drawn collage, paper and pen, Photoshop

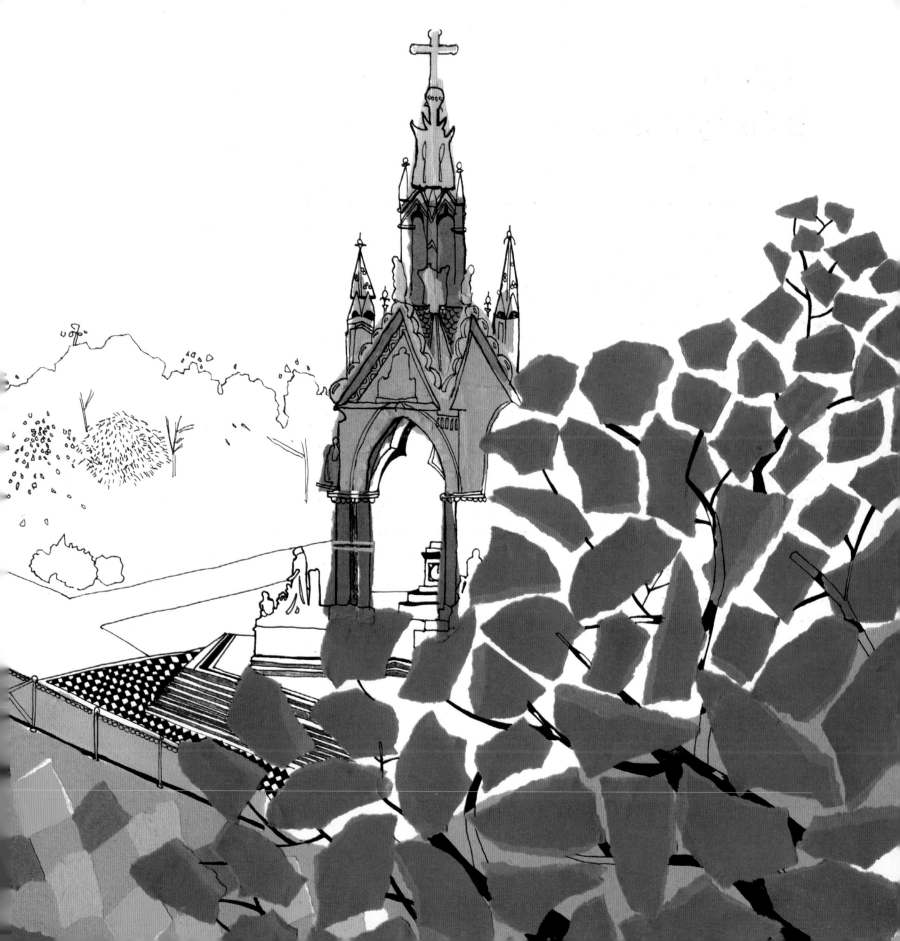

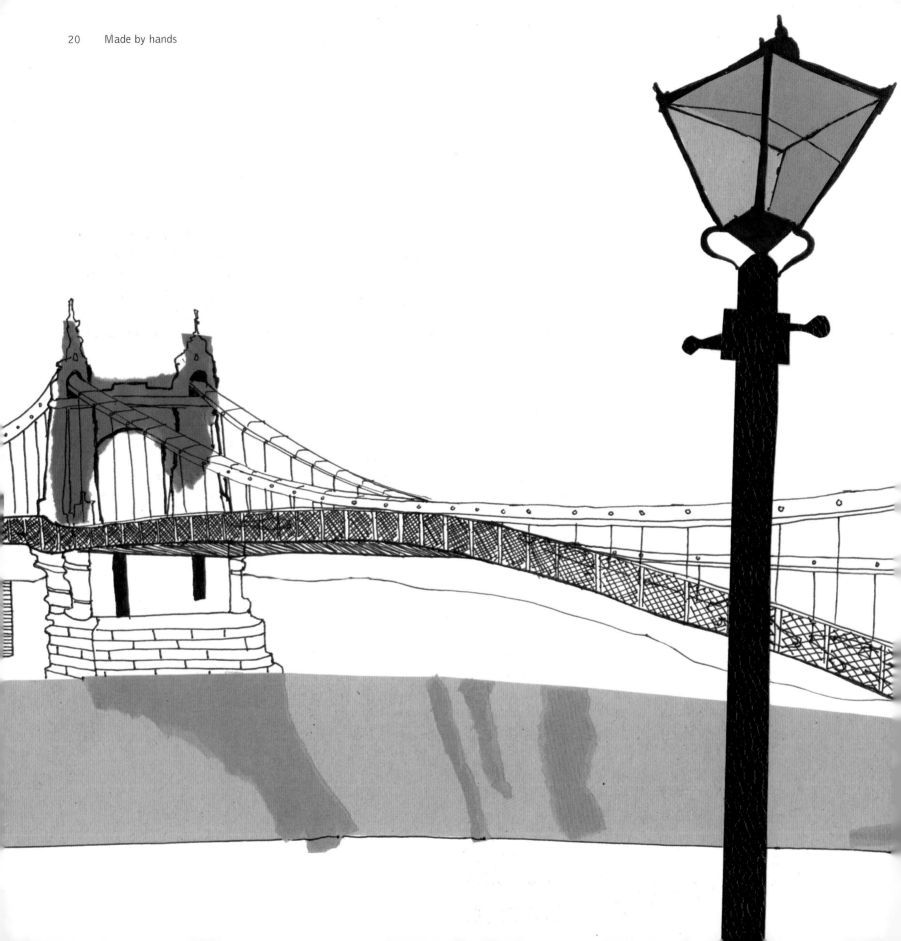

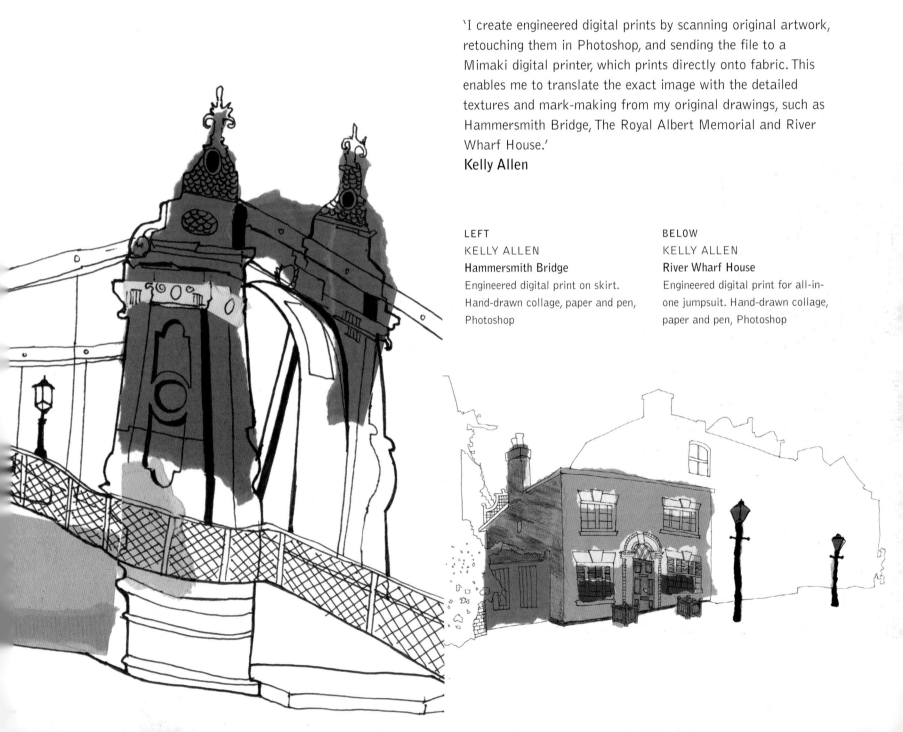

'I create engineered digital prints by scanning original artwork, retouching them in Photoshop, and sending the file to a Mimaki digital printer, which prints directly onto fabric. This enables me to translate the exact image with the detailed textures and mark-making from my original drawings, such as Hammersmith Bridge, The Royal Albert Memorial and River Wharf House.'
Kelly Allen

LEFT
KELLY ALLEN
Hammersmith Bridge
Engineered digital print on skirt. Hand-drawn collage, paper and pen, Photoshop

BELOW
KELLY ALLEN
River Wharf House
Engineered digital print for all-in-one jumpsuit. Hand-drawn collage, paper and pen, Photoshop

HOWARD TANGYE
Boats on the Seine
Engineered digital print for
accessories and apparel.
Watercolour, Photoshop

'Digital printing was used
to transfer the original
watercolour painting onto
fabric. The painting was
digitized, adjusted and
manipulated in Photoshop
using repeat pattern
techniques. The images
were magnified to achieve
the final result.'
Howard Tangye

HOWARD TANGYE
Near Sacré Coeur Basilica
Engineered digital print for
accessories and apparel.
Watercolour, Photoshop

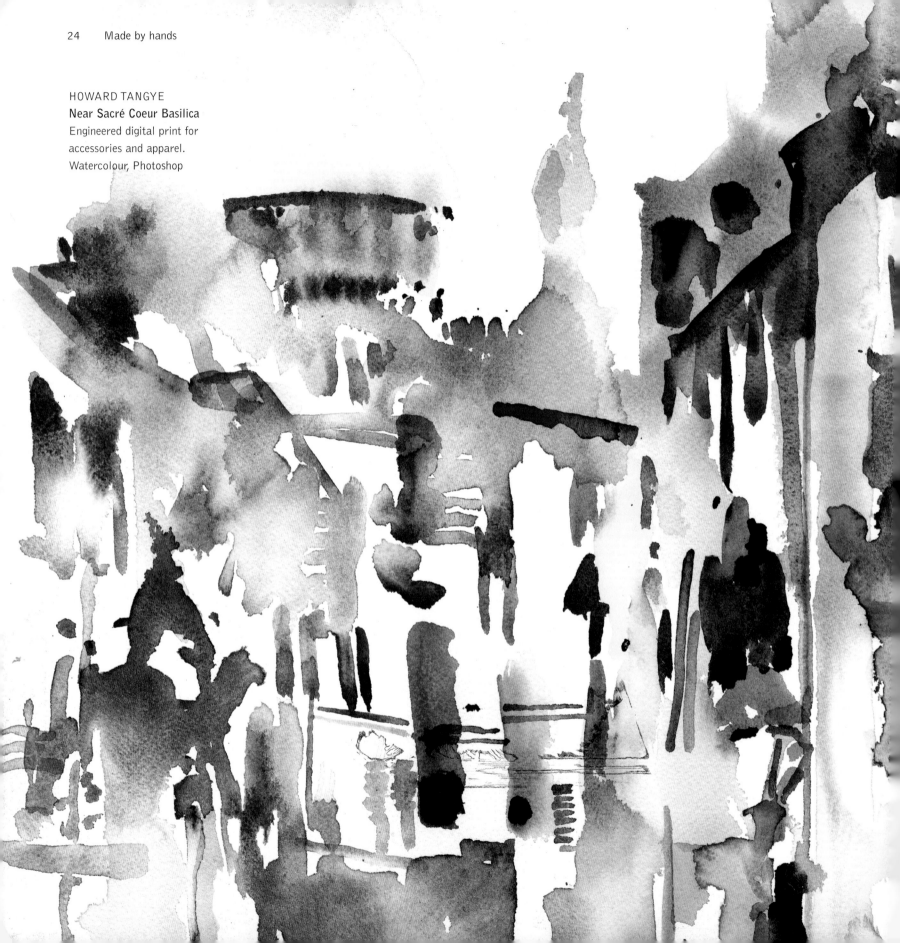

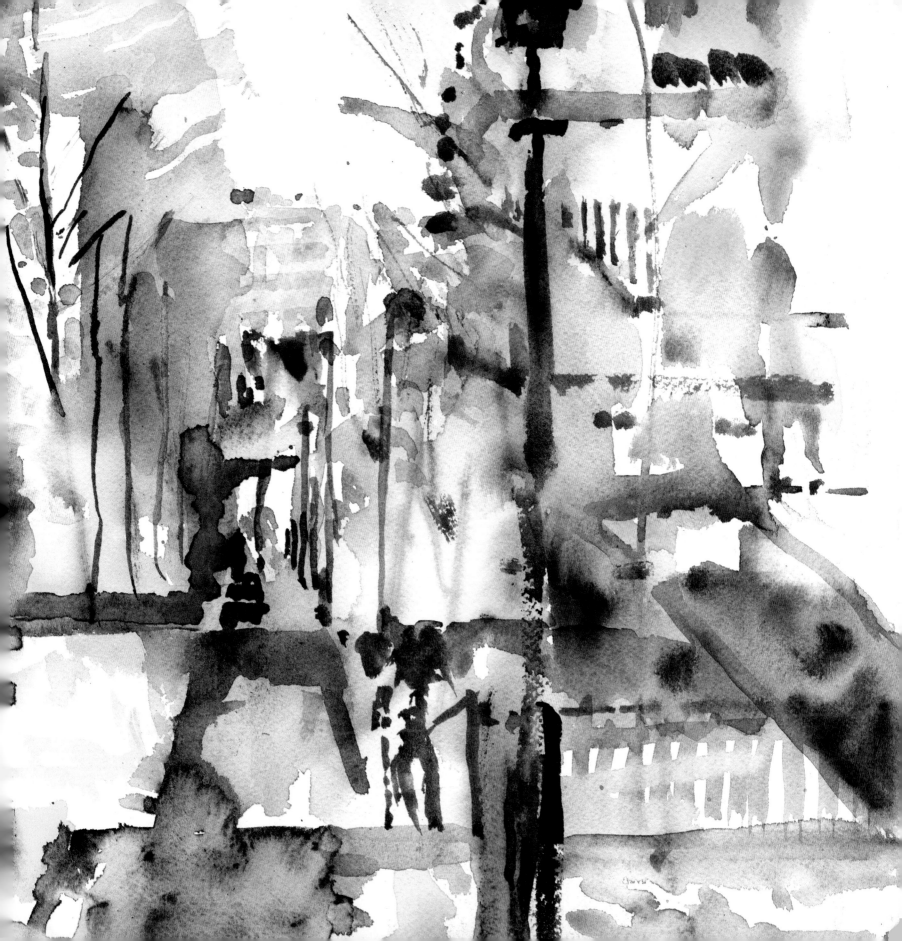

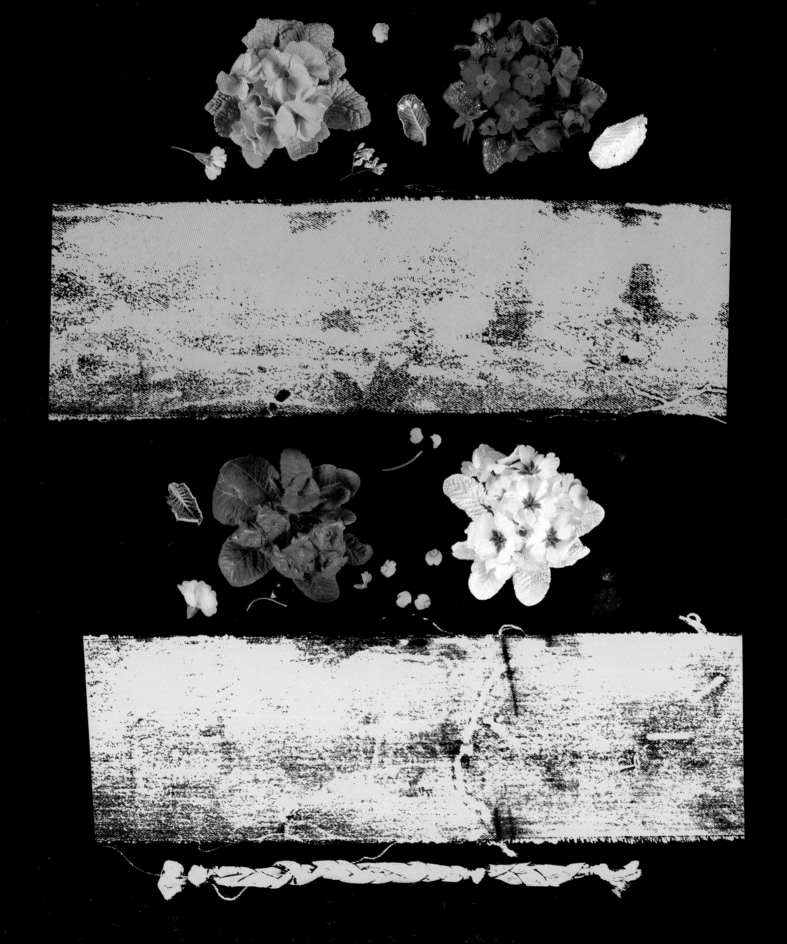

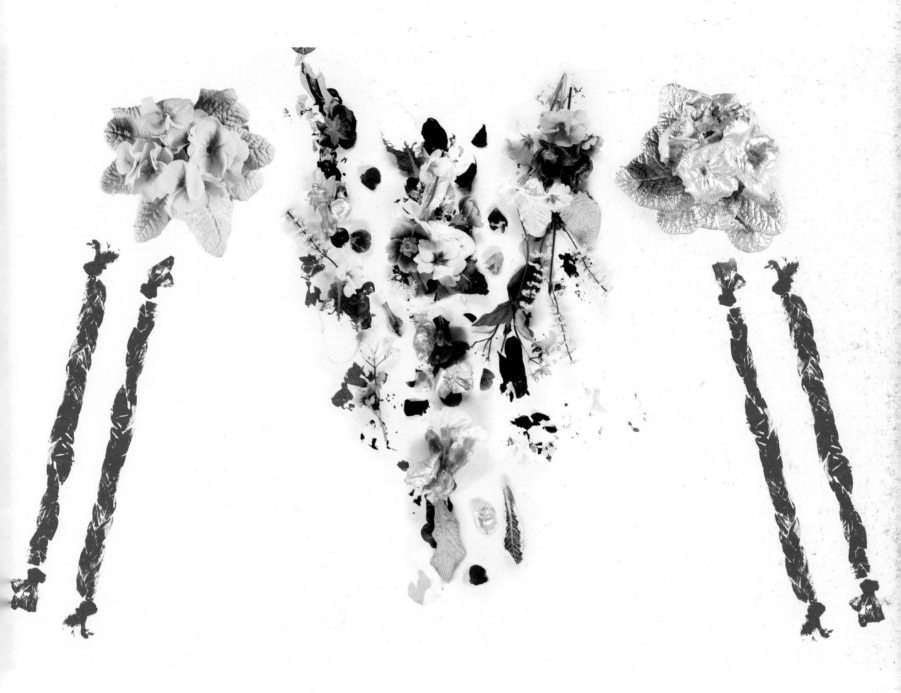

LEFT
HELEN SEMPLE
Denim Stripe and Floral
Fabric, paint, flowers, Photoshop

'My work is influenced by contrasting elements. I transform found objects in order to develop my artworks. I mono-print crumpled, torn and plaited fabric, combined with photographs of flowers and paint. I like to mix the distressed and the hyper-real. Working in Photoshop enables me to merge images, manipulate colours and experiment with composition.'
Helen Semple

ABOVE
HELEN SEMPLE
Floral Plait
Fabric, paint, flowers, Photoshop

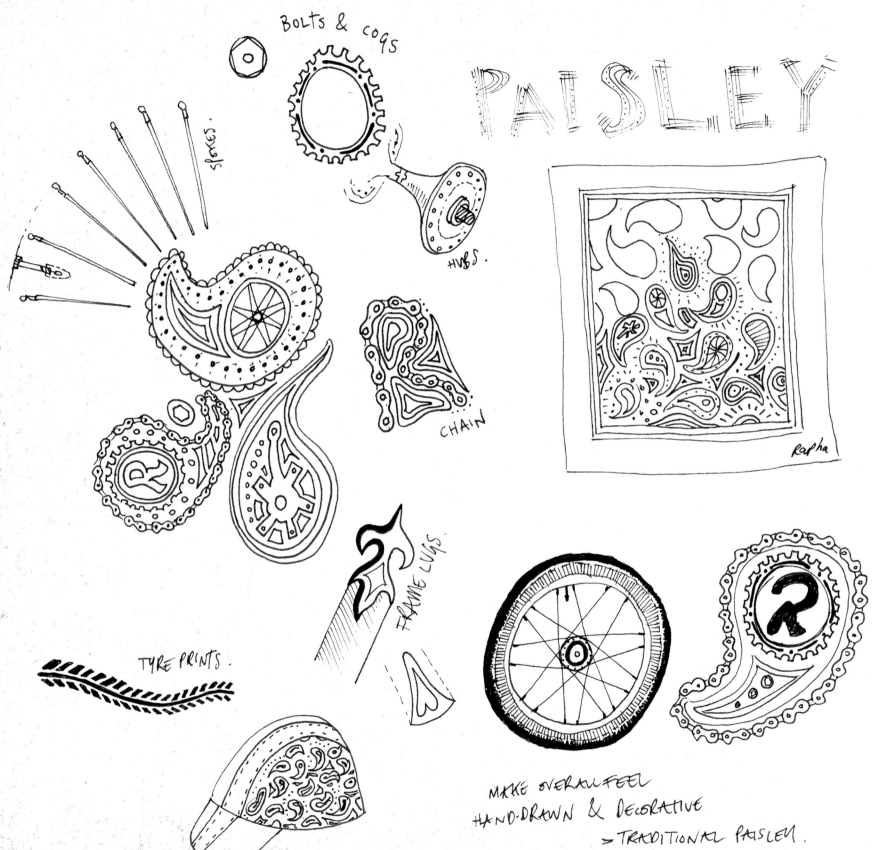

BOLTS & COQS

SPOKES.

HUBS.

PAISLEY

CHAIN

Rapha

FRAME LUGS.

TYRE PRINTS.

MAKE OVERALL FEEL
HAND-DRAWN & DECORATIVE
= TRADITIONAL PAISLEY.

LEFT
ANDREW TODD
Bicycle Paisley for Rapha
Research sketches. Pencil, ink

'When creating print work
for fashion I try to use the
computer as little as possible.
I don't find overly produced,
clinical graphics very exciting
and still like to see the rough
edges of something created
by hand. However, the
computer always plays a key
role in the final outcome of
my work. It could be when
playing with colour balance,
creating a repeat pattern, or
overlapping images using
translucent layers ... I like to
experiment and see how far
I can push things without
taking away too much of the
original quality.'
Andrew Todd

RIGHT
ANDREW TODD
Bicycle Paisley for Rapha
Pencil, ink, Photoshop

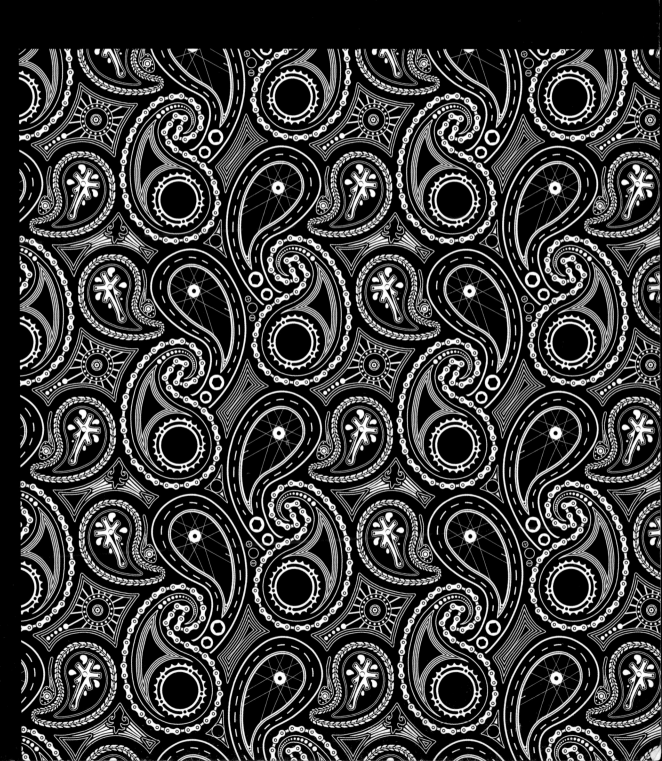

LEFT
YING WU
Garden Skull
Pencil, ink, Photoshop

'To make my print ready for screen or digital print, I start my work with hand-drawn sketches, which I then scan to clean up in Photoshop. I usually also add colours and do collages on the computer, using various effects found in the application. I use Photoshop quite a lot, but hand-drawn illustrations remain the foundation of my work.'
Ying Wu

RIGHT
YING WU,
Home from Memory (Workroom)
Pencil, ink, Photoshop

LEFT
ALICIA MARY SEAL
Untitled
Pencil, ink, Photoshop

RIGHT
ALICIA MARY SEAL
Untitled
Pencil, ink, Photoshop

'My work is deeply influenced by the simple and calm feeling of the Scandinavian landscape, combined with its muted colours. Abstract shapes and rhythmic structures form a large part of my work. When combining traditional techniques with digital methods I want to keep designs as natural and hand-drawn as possible. Manipulating line drawings and mark-making with sketching filters allow me to create these effects. Using filters to make each layer tonal, I can easily change the colours to combine them and add depth.'
Cathryn Eardley

LEFT
CAROL BAILEY
Painterly Florals
Gouache, acrylic, fine-line pen,
Photoshop

'I begin every project with a
theme that is usually driven
by current fashion trends.
From this I begin to research
and develop a style, using
illustration, photography,
painting and other forms of
visualization. My exploration
of the theme continues
digitally by manipulating my
original drawings to create
new forms and layered
compositions. This is
enhanced with the use of
Adjustments such as
Hue/Saturation and Selective
Colour to isolate and adjust
the overall colour palette.'
Carol Bailey

RIGHT
CAROL BAILEY
Drippy Florals
Fine-line pen, coloured pencils,
acrylic, watercolour, Photoshop

Chapter 2
Return to retro

With a clear and recent rush for all things digital, fashion print designers might have forgotten all about the good old-fashioned analogue world. Yet most recently a return to more 'genuine' and retro-inspired themes has been in evidence. Call it nostalgia or revival, but there is no denying that fashion always needs to be inspired by the past.

The work presented in this chapter has a definitive old-school flavour to it, and the period that designers are delving into is definitively the second half of the 20th century. There are some playful reinterpretations of 1950s, 1960s and 1970s retro prints or iconography, but always done with style and taste. Obviously, designers and global trend-setters such as Miuccia Prada, Frida Giannini and Tom Ford are leading the charge in all things retro emerging from these key decades.

As always with fashion, we have been there before, but today's reinterpretation adds a new dimension to the visual language of these bygone eras, probably because the more obvious references have already been abused and copied. As a result, today's designers need to dig deeper to understand and represent the essence of a past era to a discerning consumer who constantly seeks a new angle from these pivotal fashion periods.

Generally, we feel instantly comfortable with prints that represent the past, no doubt due to our subconscious and falsely secure belief that the past is always a better place than the present, or indeed the future.

Interestingly, the contributors to this chapter have mainly worked in Illustrator to produce their designs, an intriguing fact when one usually associates Illustrator with clean and crisp vector artworks. Illustrator is now widely used for a variety of styles as seasoned users have learned to choose more natural colour hues rather than the obvious bright and attractive ones usually favoured by less experienced users. The advances in Illustrator's capabilities, such as gradient meshes and Photoshop-style effects, have meant that a print can genuinely look retro in style. Knowing how to use the Live Trace tool and sourcing the right kind of clip art or typeface are also good ways to mimic what was originally done by hand.

A good fashion print always starts with accurate research, and fashion allows us to reinterpret the past constantly. So if retro is your kind of style, go out there and research, and relive the bygone eras still to be found in second-hand shops, libraries and those swiftly diminishing cafés, shops and restaurants where time seems to have stood still.

TINA MUNTHER
Rue de Paris
Illustrator

LEFT
LENA KARLSSON
Key Rings
Illustrator

'I'm a collector. Always have been and always will be. I collect flyers, posters, pictures and magazines everywhere I go, just out and about or on the Internet. I mainly use Adobe Illustrator and every now and then Photoshop to scan in source images. When designing I always try different kinds of techniques, everything from tracing to using filters, clean vectors or more distressed looks. I always end up with plenty of colour variations and finishes of the same image. That's the wonderful thing about computers – play around and have fun!'
Lena Karlsson

RIGHT
JACQUELINE COLLEY
Mirrors and Cages
Clip art, Photoshop

KELLY ALLEN
Colander
Illustrator

KELLY ALLEN
Teacups
Illustrator

LEFT
KELLY ALLEN
Umbrella and Herringbone
Hand-drawn, Photoshop and Illustrator

ABOVE
MUDPIE
Print 070
Illustrator

LEFT
MUDPIE
Print 065
Illustrator

RIGHT
MUDPIE
Print 066
Illustrator

ABOVE
ATELIER 4 à 4
Il était une fée des bois
Illustrator, Photoshop

LEFT
LEVI PALMER
Peacock Safari
Illustrator, Photoshop

'My aim is to develop prints that imply the techniques used in traditional printmaking but are led by the innovations allowed through digital experimentation. My work is often inspired by vintage moods and imagery, with reference to contemporary art for colour palettes and graphics. In mixing these themes I can create a work that feels familiar and nostalgic while also contemporary and intriguing.'
Levi Palmer

ABOVE
LEVI PALMER
California Social
Photoshop, Illustrator

'I find inspiration from past and modern times – by looking in vintage and antique stores, when I'm browsing my way through art and architecture books, or from photographs and magazines. When I make a print I often start by sketching up the idea on a piece of paper to get an overview quickly. When the idea is clear I start work, either directly in Illustrator or by hand. I also use source images that I turn into vector graphics with the Illustrator Live Trace function, sometimes simplifying the image in Photoshop first.'
Tina Munther

Chapter 3
Modern vectors

Vector graphics have always aspired to be slick, clean and modern; but Adobe Illustrator, the design package with which all things vector are created, has also influenced designers to experiment with new features released with each updated version and, as a result, somehow, somewhere along the line, the pure essence of vector graphics was lost. Yet the re-emergence of the graphic design aesthetics of the early 1990s, a period which is closely linked to the early Illustrator releases, is now very much on trend.

So what's all the fuss about vector graphics then? And why dedicate a whole chapter to them here? Well, one thing is for sure: because vector graphics are usually drawn from scratch, unlike image-based graphics, designers have to work a bit harder to create designs.

Vector graphics are big news in the sportswear industry and tend to include placement prints, all-over prints and, of course, logo artwork. But the link to sportswear could also be attributed to the natural propensity of vector graphics to convey energy and dynamism, two key words in the world of sports.

Another clear and present trend in vector graphics and street/club fashion is the low-resolution early 1980s graphics revival. Oddly, vectors seem better at reappropriating what were originally bitmap artworks. This is probably because vector graphics are really good at representing the bold and solid colours usually associated with the 1980s' screen-based bitmap 'boom'. Some print artists featured in this chapter have even pushed the envelope by mimicking low-resolution black-and-white monitor graphics usually more at home on original Apple Macintosh computer screens circa 1984.

Vector graphics have come a long way since the early Illustrator days, when anything drawn on the artboard was done with very few tools compared to today's daunting tool arsenal. Yet, as ever, the development and success of such graphics depend on factors outside the scope of Illustrator. A good understanding of trends and design relevance in a crowded market will have more influence on the success of any given print. The turnaround from original idea to print house hand-over has become so short, due to the ubiquity of fast fashion, that designers working on graphics for fashion need to be sure that their research is pertinent, must be accurate in their interpretation, and as fast as lightning in the development stage. Hopefully, the tutorials on vector graphics and print tiles in Chapter 7 will help you to acquire some of these skills.

There are plenty of vector graphics to be found throughout this book, but this chapter presents artworks glorifying the original emergence of vector graphics when things were pretty simple – no fancy effects, filters or appearance, just the designer and the vector Pen tool.

OBERON KOK
Radio Active Pattern
Illustrator

LEFT
OBERON KOK
Rough Striped Check Pattern
Illustrator

'I hand-drew the squares
in Illustrator with the Pencil
tool, creating an irregular
look. The diagonal stripes
are actual brush strokes
that I scanned in, traced
and stretched. The colour
variations and raw shapes
give the pattern a fresher and
more playful feel than a
regular check pattern.'
Oberon Kok

RIGHT
MARIO SCHELLINGERHOUT
Nike EMEA Footlocker
NSE Collection
Illustrator

MARIO SCHELLINGERHOUT
Nike Footlocker TN Collection B
Illustrator

MARIO SCHELLINGERHOUT
Nike Footlocker TN Collection C
Illustrator

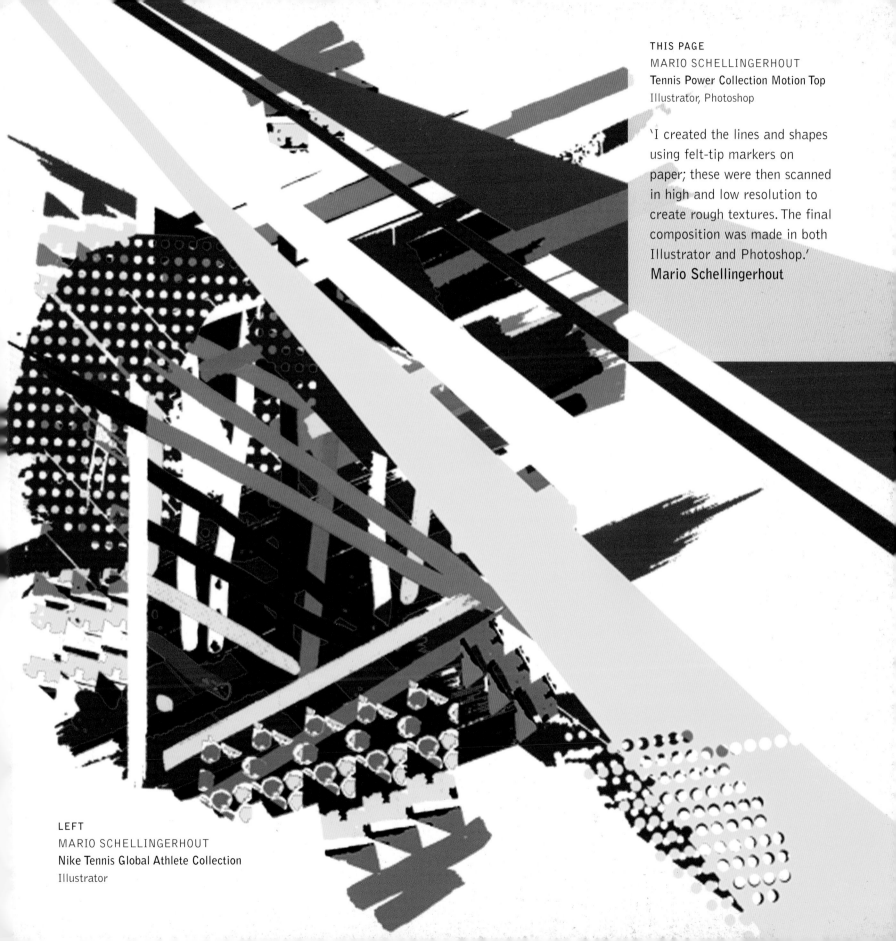

ABOVE
JELLYMON
Doggy Dog World
Illustrator

RIGHT
JELLYMON
A Tribe Called Miao
Hand drawing, scans and Illustrator

ABOVE
LENA KARLSSON
Cutie
Illustrator

RIGHT
LENA KARLSSON
Maps
Illustrator

LEFT
JACQUELINE COLLEY
Tiger Traps
Illustrator

'My work begins with hand-drawn sketches to pin down an idea; for example, the background here was initially in my sketchbook but was developed in Illustrator, turning a simple maze idea into detailed vector geometrics. I like creating quirky prints that have a hand-drawn feel but are further developed on the computer, making something more clean and printable or layered and intricate.'
Jacqueline Colley

RIGHT
JACQUELINE COLLEY
Graphic Squiggle
Illustrator

LEFT
JACQUELINE COLLEY
Temple of Triangles
Illustrator

ABOVE
JELLYMON
Cloudy Day
Illustrator

Chapter 4
Chestmate!

Some might claim that T-shirt prints are not worth a mention in the world of fashion textile printing. Historically, textile printing was the preserve of traditional craftsmen and was therefore within reach of only those who could afford it, whereas T-shirt printing was closely associated with mass production and affordability for all.

Needless to say, this is an archaic preconception and T-shirt printing is now an important part of the fashion print world. The prints placed on the 'chest' of T-shirts have had (and continue to have) so many thematic and socio-cultural variations since they first started appearing in the second half of the 20th century that T-shirt printing cannot be ignored. Seminal early T-shirt prints, such as Malcolm McLaren and Vivienne Westwood's Seditionaries T-shirts in the 1970s or Katharine Hamnett's 1980s bold slogan prints, still influence designers today. Just like other forms of fashion design, graphics for T-shirts are constantly reinterpreted.

T-shirts are usually bought on impulse, so designers need to think about how to create an impactful print that immediately appeals to the buyer. A great idea for a print should drive the design process; designing a T-shirt print is more closely associated with advertising than fashion – the idea, the slogan and the context are key here.

When it comes to skills, a good understanding of typography helps, as does a good command of grammar in whichever language the slogan will be written. The days of badly written English slogans produced by foreign brands are thankfully on the way out.

Much of T-shirt printing is concerned with branding and how to update or modify a famous brand's logo, and the graphic designer has a powerful role here. However, it is important always to focus on your final product and to remember that you are working on textile and not paper. One of the common pitfalls that graphic designers encounter when working on fashion print is failing to consider the difference between working on paper and on fabric. What might look great for a book illustration, on a DVD, or as street graffiti can look awful on a garment. Printed T-shirts are to be worn; for most of us it is much easier to admire an amazing print in an art book, for example, than to wear one. So always try to bear in mind this simple yet important question: 'Would I wear this?'

When a professional print designer develops prints digitally he or she always considers and plans the print with regard to its final output application. What is its size? What print technique should be used? What kind of fabric will the print be applied to? Taking into account all of these important questions is essential to produce a successful print. Don't hesitate to print your artwork on paper and try it out on a T-shirt to see how it 'feels'.

There is a good mix of Photoshop- and Illustrator-based work in this chapter, so the tutorials on compositing in Photoshop and how to use Effects and Filter Gallery (Tutorials 5, 6 and 9) will come in handy. Take note of how most artists featured here follow a theme and a trend, which is of course crucial for seasonal T-shirt prints. Remember the big trends for fake brand logos, or, more recently, enlarged postcard photography digitally piece-printed on entire panels? There is always a new trend emerging, so be sharp and look around.

Most artists working on a T-shirt print will probably at some point be driven to create the ultimate iconic and timeless design piece; so why not aspire to join the élite group of chest-print artists who have produced all-time T-shirt classics, such as Martin Margiela's AIDS T-shirt or the Comme des Garçons Play heart logo?

'Run for Your Life is a classic Nike slogan, usually displayed in Futura Extra Bold Condensed type. I took this as a starting point. As this was designed to be in store around Halloween, I thought it would be cool to give a twist to the slogan with an old-school horror-type feel. I very roughly hand-drew over the original type, scanned it, and made it a vector graphic in Illustrator.'

Oberon Kok

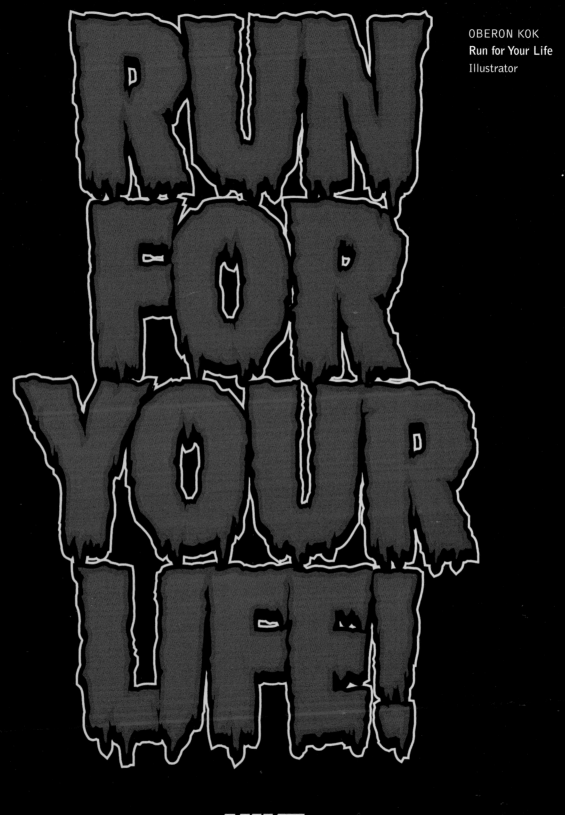

OBERON KOK
Run for Your Life
Illustrator

OBERON KOK
Sticks and Stones
Illustrator

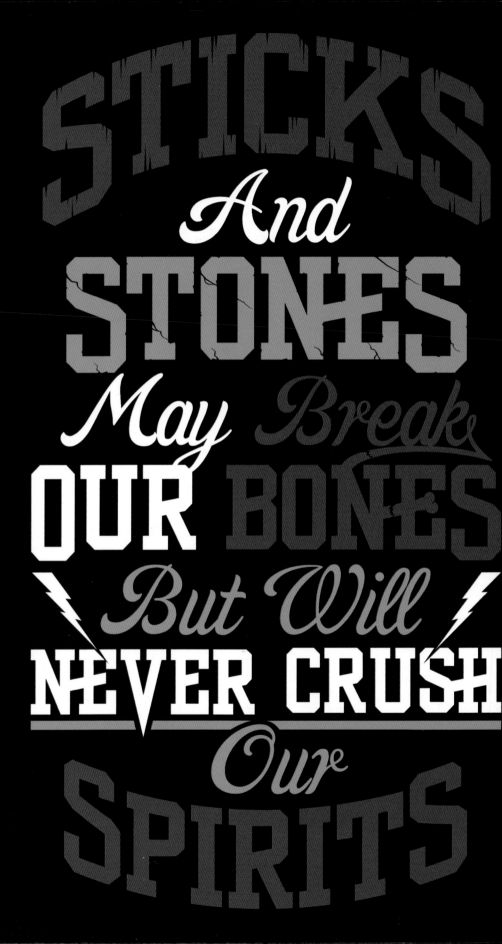

OBERON KOK
Fatlace Noshi
Illustrator

'My work is devised through layering eye-catching imagery, usually centred upon current trends, to offer a final shape that is abstract yet in some form symmetrical. I find the use of symmetry helps when producing artworks for the fashion industry. I usually opt for desaturated source images to keep a main thread running through the final artwork. I tend to use Photoshop for what I feel are its better attributes when compiling my artwork; this would include overlays, filters and colour balance. Inverted images offer a nice alternative when overlaid and slightly offset on the original artwork to make the print come alive.'
Nicholas Thomas Biela

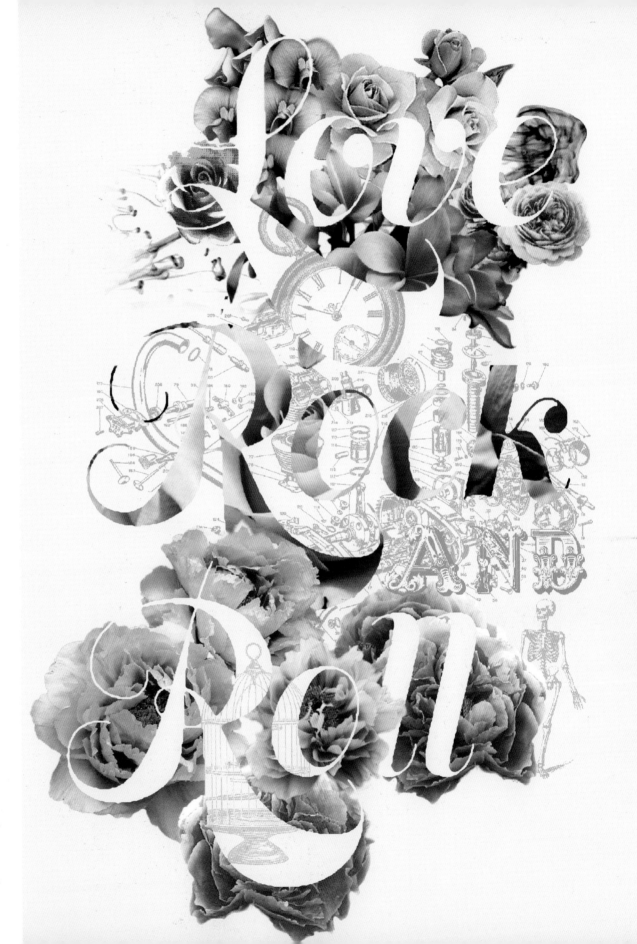

LEFT
LENN ROSENKRANZ
Victorians Do it Better
Photoshop, Illustrator

'I am a big fan of vintage images, retro posters and stencils, with which I especially like to build collages and display them in a modern context to create a complete new story. I work from Barcelona, which has the perfect mix of 19th-century architectural tradition and cutting-edge graphic design. There is plenty to be inspired by on a daily basis. I combine Illustrator and Photoshop to create my T-shirt print artworks for clients.'
Lenn Rosenkranz

RIGHT
JACQUELINE COLLEY
Love, Rock and Roll
Photoshop

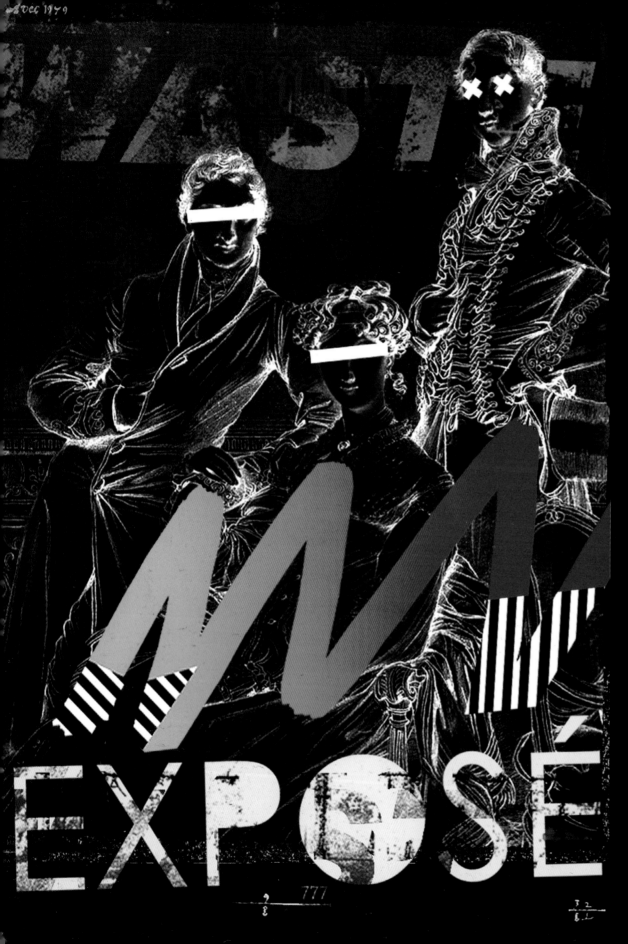

JOE HODGKINSON
Expose
Photoshop

'My work is formed by a combination of found photographic images and hand-drawn elements. I initially use Photoshop as a cut-and-paste tool to mock up basic ideas and composition, chopping up sourced images with the Pen tool and fiddling with the brightness and contrast, and the hue and saturation, to co-ordinate the contrasting qualities of the different images. I'll then go about hand-making elements such as ink splashes, text and scribbles to bring the artwork to life. If I have large blocks of colour within an artwork, I'll break them down by painting over with a 'fuzzy' brush set to the Dissolve mode, with the opacity and flow both set between 30 per cent and 50 per cent. This helps to limit the amount of ink transferred to the canvas. I'll often overlay a number of textures on the artwork to give it a worn-in, deconstructed and decayed feel.'
Joe Hodgkinson

MICHAEL BRIMMER FOR
NICKELSON
Bike Collage
Photoshop. © Ben Sherman Group
Limited 2010. All rights reserved.

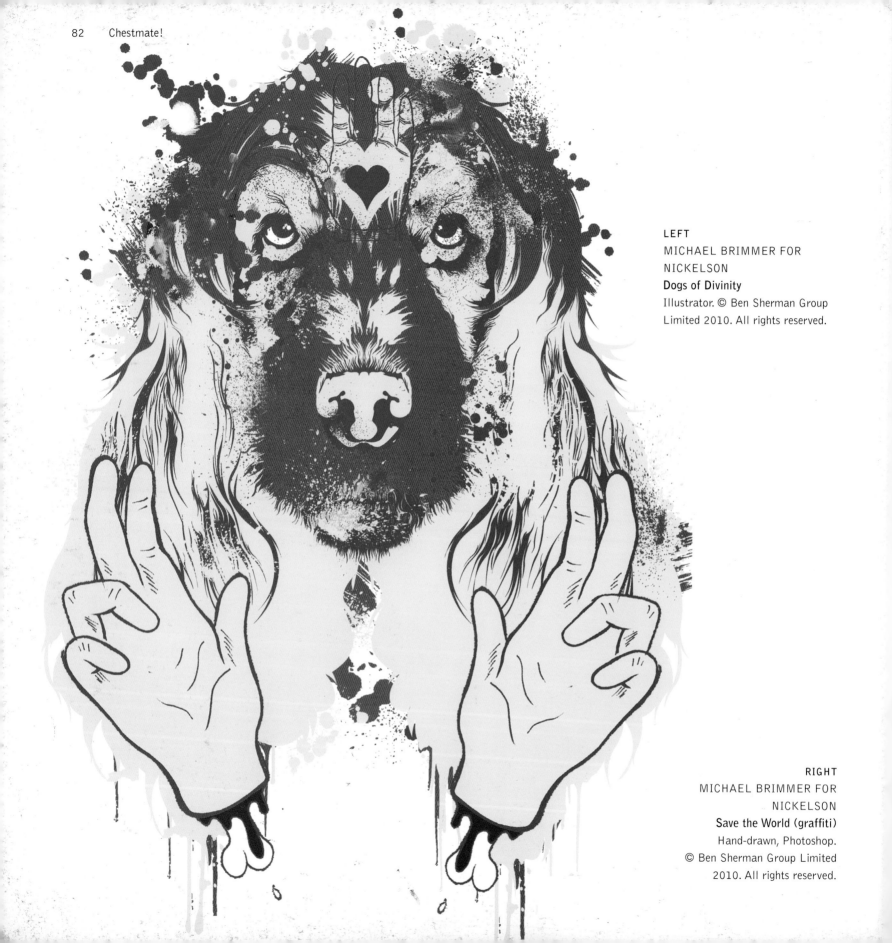

LEFT
TREVOR DICKINSON
Osh Kosh Australia 1
Illustrator

'I tend to look closely at the surface detail of images: how the marks were made, how a distress was created, how ink was applied to a print, etc. Rather than work with roughs, I prefer to start the process and let the ideas for the content emerge along the way. I work using both Photoshop and Illustrator equally. Unless the design is photographic, the final image is always in Illustrator. The freedom to scale, rotate, and recolour objects without losing quality gives Illustrator the edge.'
Trevor Dickinson

RIGHT
TREVOR DICKINSON
Osh Kosh Australia 2
Illustrator

Chapter 5
Painterly pleasures

Painting on textile is a big part of fashion print and as such it deserves its own chapter. Whereas the previous chapter was quite masculine and graphical in style, this chapter delves into the more feminine and artistic side of printed textiles. Before computers came along, paint was the medium of choice for creating textile prints, and in today's digital age painted textiles are enjoying a revival and a refreshed look.

Traditionally, womenswear has always had more to offer when it comes to painted prints on textile. The close, instinctual and deeply rooted association between femininity and embellishment drove print artists to constantly suggest and redefine the aesthetics of femininity expressed through textile prints.

On the other hand, the world of menswear textile design was concentrated on subtle variations in weaving techniques to induce some kind of differentiation, such as mélange, checks, pinstripe, yarn dye jersey, hound's-tooth, etc. Print was only ever used for practical and useful reasons, such as for sportswear or in the military. Not until the mass acceptance of indigenous garments, such as the printed Hawaiian shirt, during the early to mid-20th century did things start to look a bit more cheerful on the men's side. Colour too was clearly defined – shirts were strictly white, or brown and green for the armed services – and it was only when celebrities such as Steve McQueen started wearing pale pink shirts that perception shifted.

For women, flower textile print was a subject of its own, with countless variations and genres culminating in the 1970s with either subtle and retro-inspired Laura Ashley prints or bold florals with colour schemes closer to wallpaper designs than fashion print. Somehow the minimal austerity of the 1980s and especially the 1990s associated and relegated anything floral to your grandmother: very uncool and dated. Only recently has floral and painted textile print enjoyed a revival, with luminaries such as Nicolas Ghesquière at Balenciaga and Marc Jacobs for Louis Vuitton leading the charge by reinterpreting classic floral and animal prints with a definitive past-meets-future twist.

Some of the contributors to this chapter are working within the same parameters by combining traditional media with digital manipulation. Most start with a painted or drawn motif, which is then imported into Photoshop to be manipulated, colour-adjusted, filtered and layered, with all kinds of Blending modes added to bring depth to the prints. Interestingly, and reflecting the tutorials found in Chapter 7, some work using graphics tablets to paint digitally directly within the computer interface. Other contributors work with sourced images of flowers and play mainly with the layering and layout. Illustrator is mostly used to create repeat tiles, as Photoshop has marginalized its Pattern Maker function by making it a download plug-in only.

Chapter 1 was about creating most of your artwork outside the computer and making only minor cosmetic digital retouches, whereas this chapter blends perfectly traditional analogue painting techniques with fully fledged digital compositing. Enjoy...

DANIELLE HENSBY
Secret Garden
Photoshop

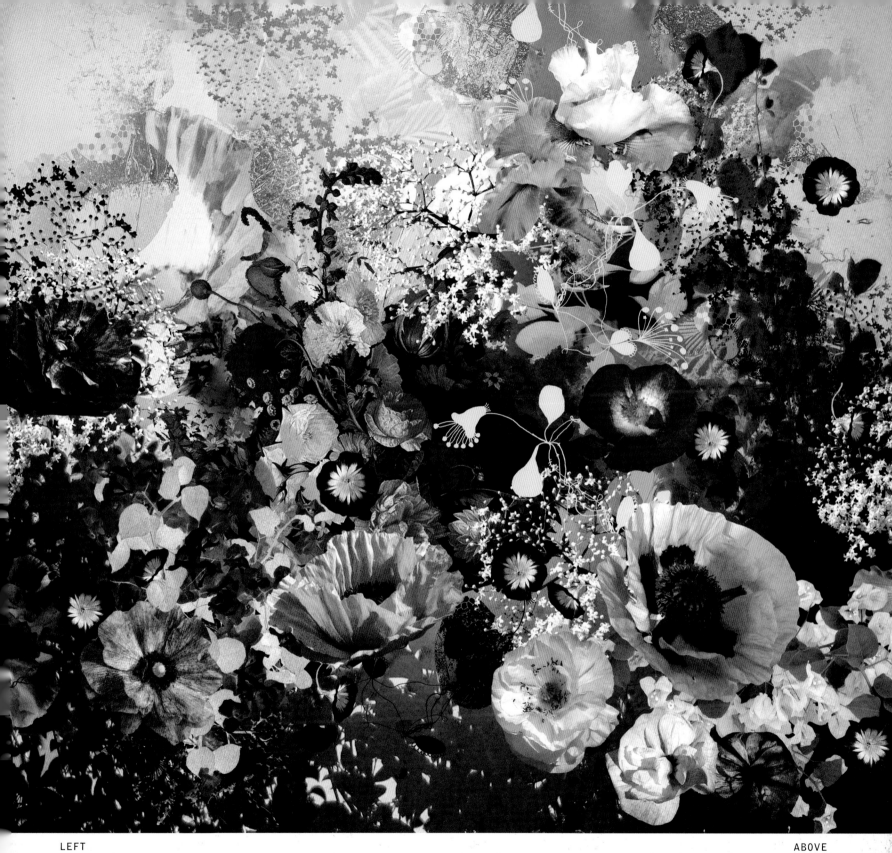

LEFT
DANIELLE HENSBY
Kaleidoscope
Photoshop

ABOVE
CLAUDIA CAVIEZEL FOR JAKOB SCHLAEPFER
Marigold
Photoshop

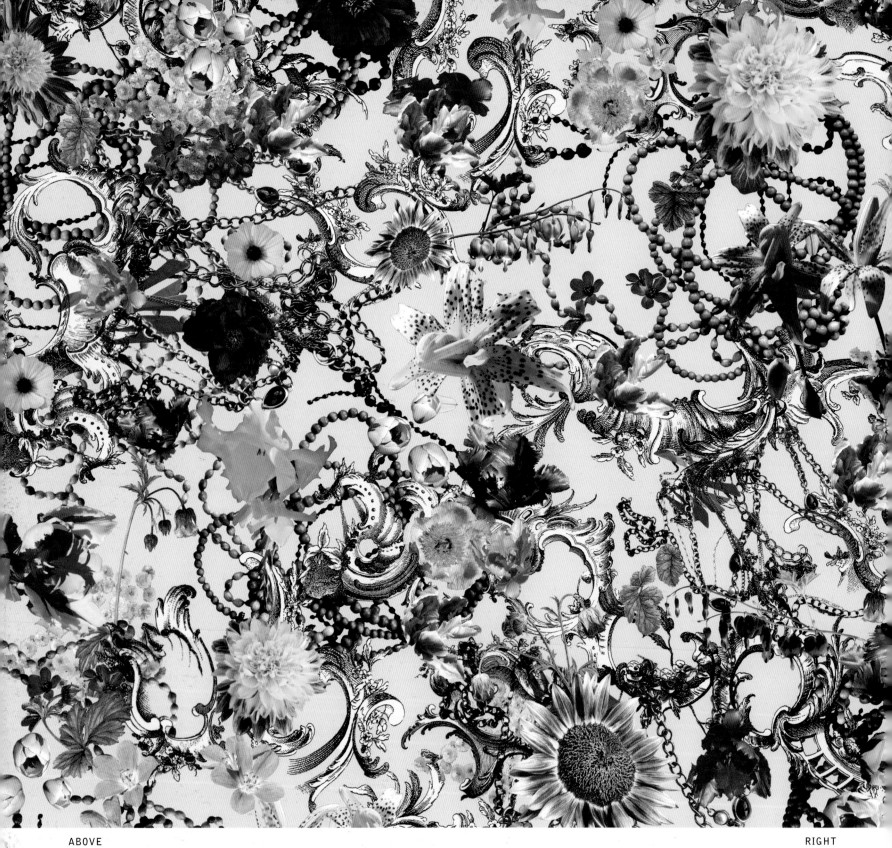

ABOVE
CLAUDIA CAVIEZEL FOR JAKOB SCHLAEPFER
Jewellery
Photoshop

RIGHT
CLAUDIA CAVIEZEL FOR JAKOB SCHLAEPFER
Plates
Photoshop

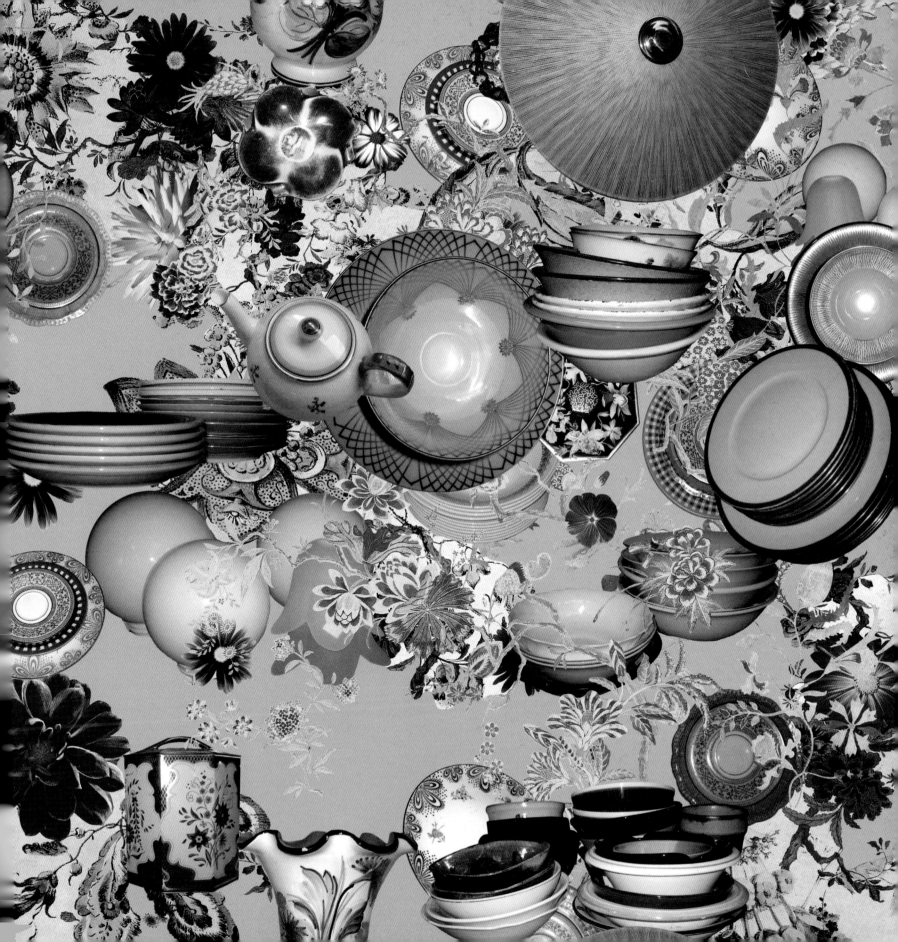

LEFT
DANIELLE HENSBY
Botanical
Photoshop

'My work is influenced by contrasting elements and an emotive use of colour. Floral imagery is a continuous subject matter throughout my work, inspired by sculptural movement and depth of colour. By exploring digital print through drawing and photographic manipulation, I can combine natural forms with digital techniques. By layering different mediums, I develop a print or pattern through a combination of filters and colour saturations. It is an organic process that is driven by technique, applying filters to multiple layers and experimenting with the stacking orders.'
Danielle Hensby

RIGHT
DANIELLE HENSBY
Vintage Floral
Photoshop

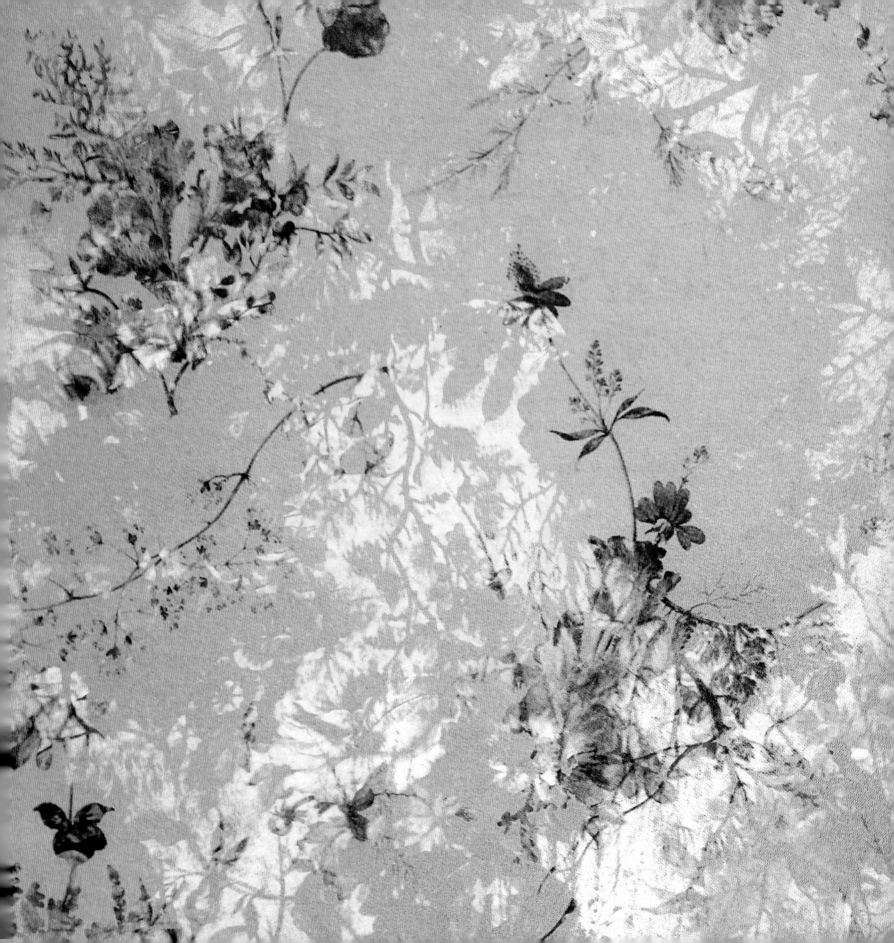

'Designing to me is an intuitive process. I get inspired by what lies right in front of me – a picture, a drawing, a form, an idea or an object. Those elements are the starting point for designing a pattern. I begin with an analogue drawing, a collage, a photograph or an object that I first digitize and optimize to a textile print. It is often the colour that leads me to the next step, creating something like a domino effect. The digital print then gets documented and layered into different, new combinations. During this process, I almost feel like a chef combining different ingredients in order to create a new, exciting dish. And exactly like a dish, the final design needs seasoning. With the help of Photoshop I play with different scales, filters, layer saturations, renderings, brightness, contrast colours and forms. I finish by generating a repeat pattern in Illustrator.'

Claudia Caviezel

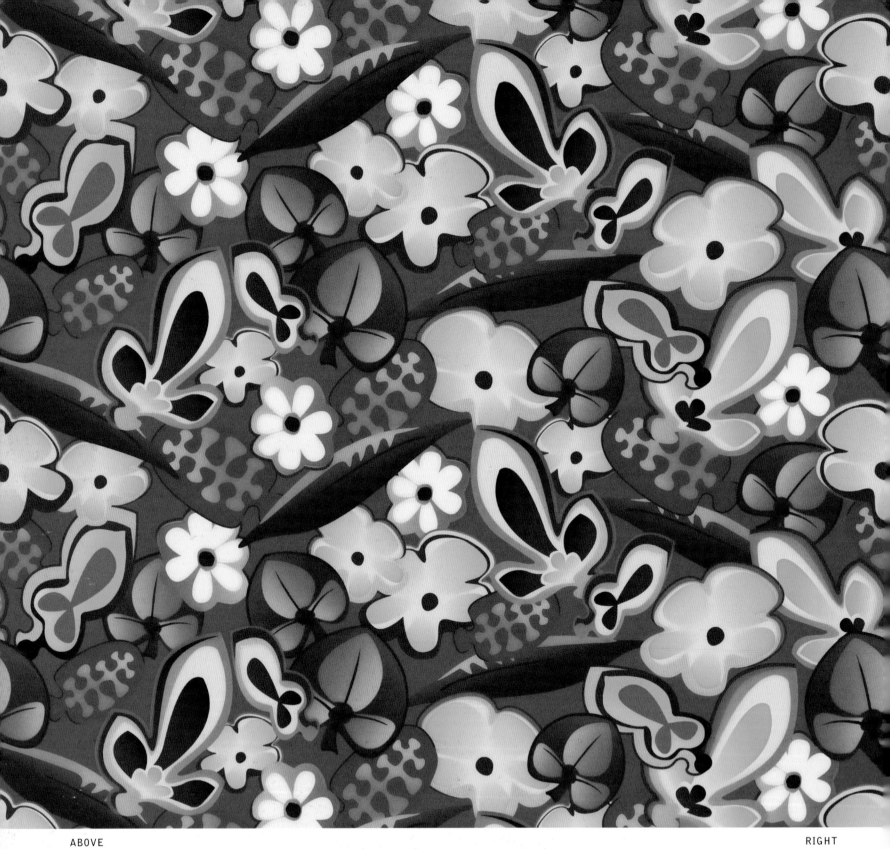

ABOVE
LEVI PALMER
Graded Bouquet
Illustrator

RIGHT
MUDPIE
Print 097
Illustrator

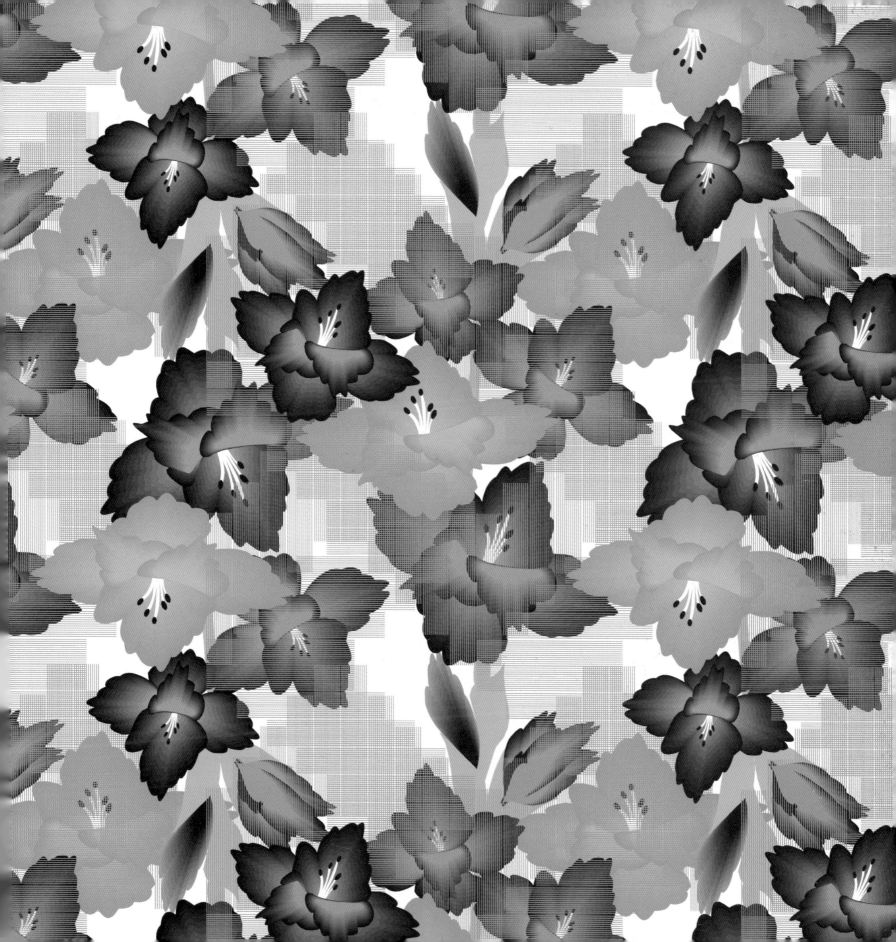

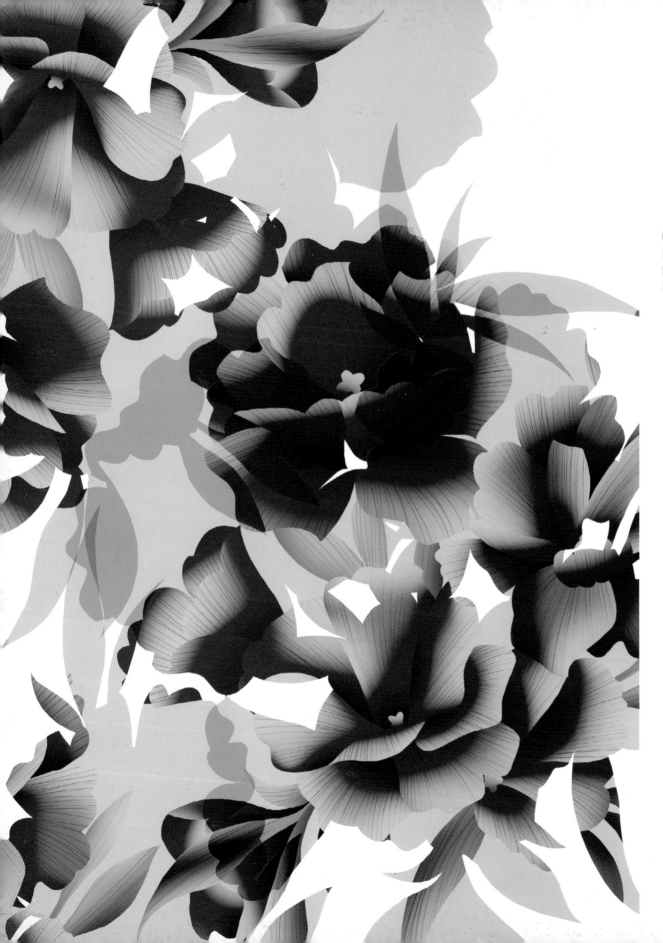

LEFT
NIAMH SMITH
Hiding Floral
Photoshop

RIGHT
NIAMH SMITH
Spinning Feathers
Photoshop

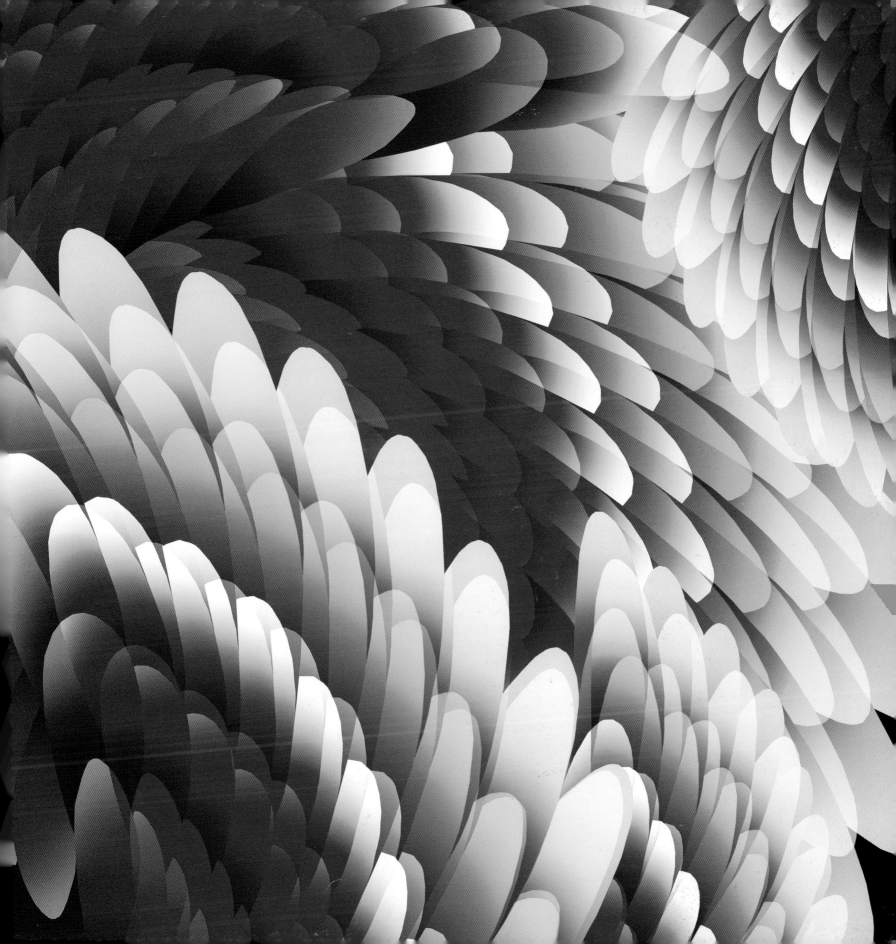

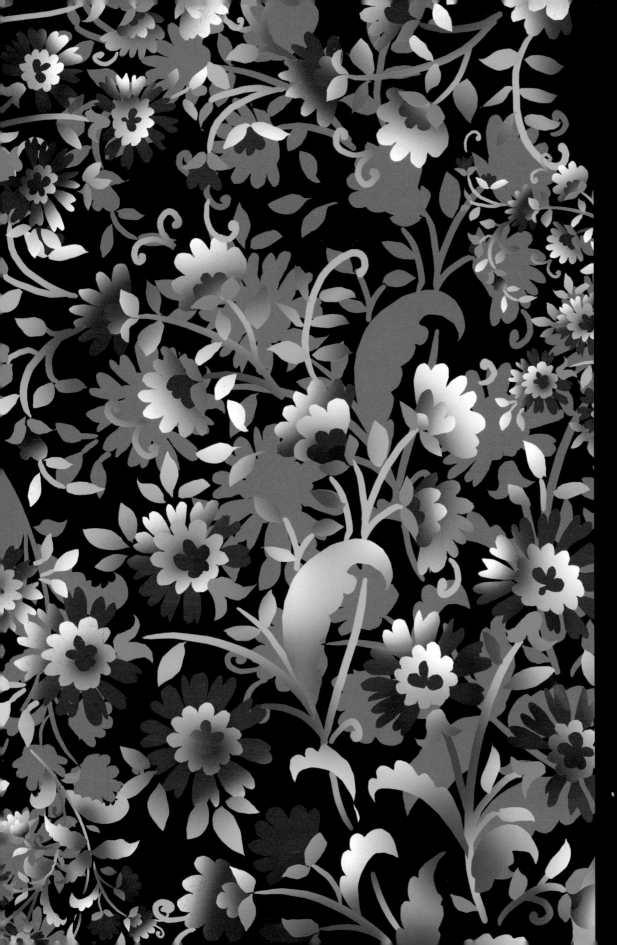

'Most of my designing is done in Photoshop and a little in Illustrator. I love how the computer gives me the scope to do so many different things, whether it be experimenting with new techniques or scanning in some hand paintings, drawings, etc. I work a lot with the Brush/Pen tool, discovering different ways to achieve effects by making my own brushes and then overlaying them to give my designs some depth and contrast. I also love the Airbrush tool; this gives my designs more movement and vibrancy. This way of working helps to make my work spontaneous and diverse. As I work for Paul Smith and as a freelance designer, I like to have lots of different styles that will suit all areas of the market. For me, inspiration comes from anywhere and everywhere; I am constantly on the lookout for new ideas and have an obsession with all things patterned.'
Niamh Smith

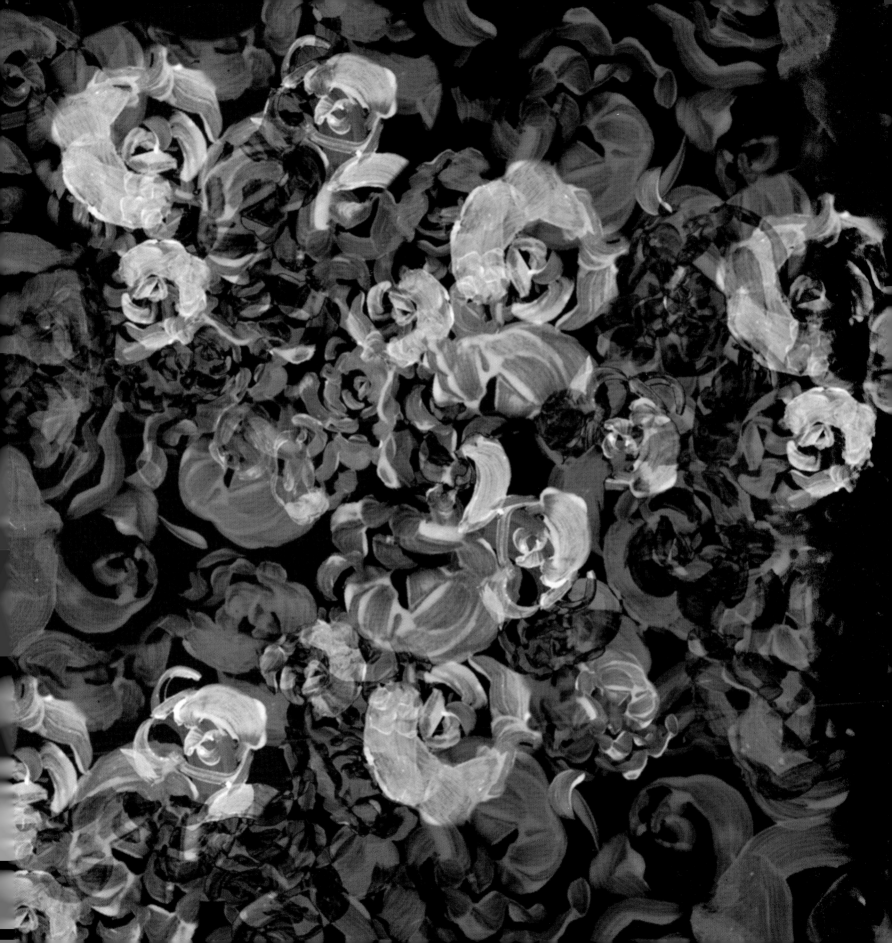

'I always start by working freehand, drawing, painting, exploring mark-making techniques to give the final designs a more sophisticated and delicate handwriting than if working purely from digitally created imagery. These images are then transformed: colours adjusted, superimposed, repeated, cut up and modified to achieve the final design. I work mainly with Photoshop as it allows me to use and combine many techniques, although I sometimes use Illustrator. Having originally trained as a painter, I believe that a print should not only work around the body but also as a 2-D image, a beautiful graphic piece that looks as good hanging off a model as it would framed on a wall.'
Leila Vibert-Stokes

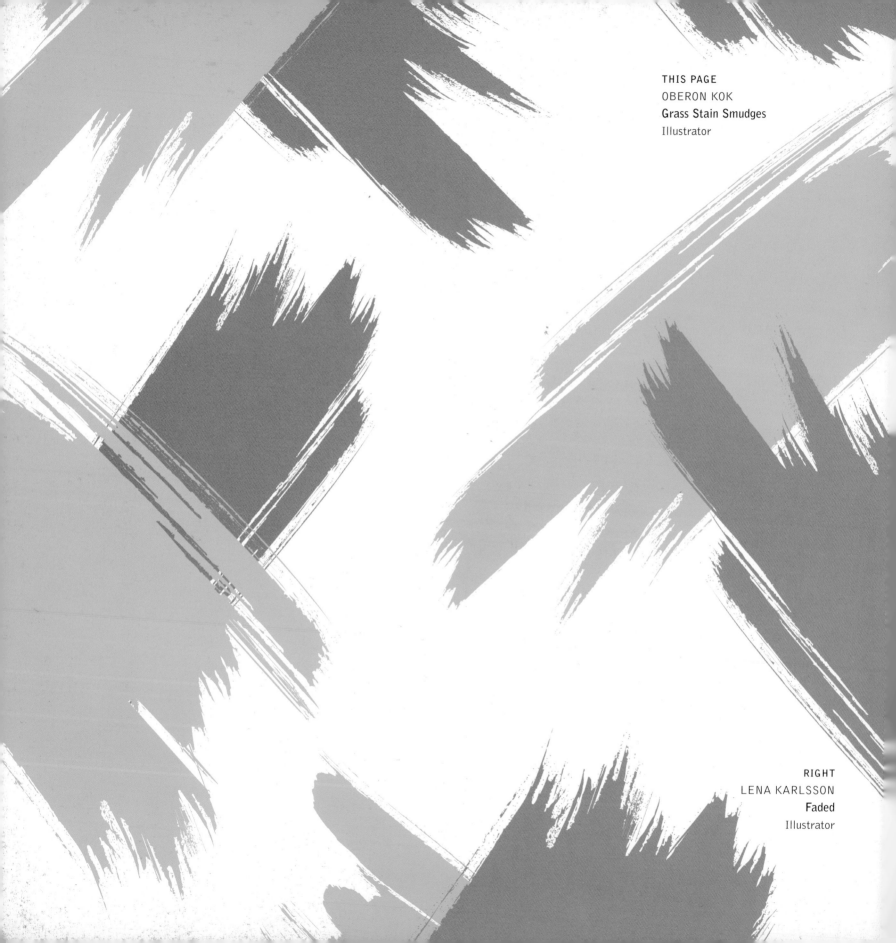

THIS PAGE
OBERON KOK
Grass Stain Smudges
Illustrator

RIGHT
LENA KARLSSON
Faded
Illustrator

Chapter 6
Future forward

This final portfolio chapter looks at more adventurous and futuristic work, with truly innovative techniques and forward-thinking digital art style, which has been cropping up on the scene more recently. As the price of printing digitally becomes more affordable and the range of fabrics to print onto wider, young up-and-coming designers are pushing the boundaries set by trailblazers such as Basso & Brooke and Jonathan Saunders.

Trends play an important part in fashion print, of course, yet it can be argued that technology is even more influential. Look at any history of textile print; it is littered with invention and techniques that have changed the game at every stage on the long road leading to today's fashion print landscape. Trends set the direction for the season's key prints; technology makes sure they are delivered!

The artworks presented here all have one word in common: experimentation. Chae Young Kim's amazingly detailed reproduction of knitted fibres, using common graphic packages coupled with code scripting, is really something special. Others work with 3-D packages to add depth and texture to their Photoshop compositions.

Engineered digital prints, which are prints made specifically to fit a garment's pattern pieces, are another area represented in this chapter. These work very well with digital printing, since each copy can be a one-off (as opposed to printing on fabric roll or screen printing, both of which always require volume printing to be viable).

Paradoxically, engineered digital printing has thrown us back to an era of master artisans working long hours on one-off pieces with highly tailored requirements. Nevertheless, the fact that the print is created digitally enables those 'artisans' to reproduce the prints at the click of a mouse.

The skills necessary to produce the kinds of artworks shown in this chapter are many, but certainly the most important one is to have a flair for trying out new things and not to be limited simply to duplicating what is already out there. It is always great to witness that magic moment when creative people suddenly 'get it' and really start to do their own thing. Any artist can stand out with true originality, by breaking the traditional rules and creating their own. Children using a computer for the first time somehow always interact with it in a different way because they are not preconditioned. A print artist could do no better than to adopt a similar state of mind in order to achieve truly original and imaginative work.

I hope that this chapter and the others before it have inspired you to go and do your part to make fashion textile print really exciting and relevant, now and in the foreseeable future.

CHAE YOUNG KIM
Urban Camouflage 05, Smallest Garden 07
Scripting, Photoshop, Illustrator

LEFT
CHAE YOUNG KIM
Urban Camouflage 05, Smallest Garden 01
Scripting, Photoshop, Illustrator

'I create fine lines digitally using 2-D vector graphics. The basic structures of knit graphics were created with computer technology, using scripts and number-crunching. I increased the illusion of knitted fibres by adding vector lines, carefully drawing and manipulating them one by one. In Photoshop I used colour adjustment tools, such as Levels, Hue/Saturation and Transform, to rescale and repeat the artwork. The computer software and digital printing process facilitate incredibly fine detailing, allowing me to reinterpret the warmth of knitted threads onto the surface of woven materials.'
Chae Young Kim

RIGHT
CHAE YOUNG KIM
Urban Camouflage 05, Smallest Garden 13
Scripting, Photoshop, Illustrator

LEFT
CLAUDIA CAVIEZEL FOR JAKOB SCHLAEPFER
Jag
Photoshop

ABOVE
JACQUELINE COLLEY
Hounds in Space
Photoshop

LEFT
CHANGBAE SEO
Flower Print v1
Photoshop

'All my prints are inspired by nature and civilization, with flowers, birds, cosmos and geometric pattern as the main elements. I thrive when designing engineered prints specifically made for a garment and pattern using Photoshop and Illustrator to flip, warp, cut out, erase and merge the print into the shape required to be engineered onto the body.'
Changbae Seo

RIGHT
CHANGBAE SEO
Bird Print v1
Photoshop

left
JEAN-PIERRE BRAGANZA
Rainbow Ribcage
Photoshop, ZBrush

'We normally draw with pencils, felt-tip pens and charcoal. Depending on the season's theme, we draw up skeletons, flowers, motorcycles, birds, etc. We scan in the photograph or drawing, then play with contrast, hue, curves, etc. The process is staggered and time-consuming, but we explore various combinations of layers and filters. We follow with the usual meandering through transparencies and blending modes. We also use ZBrush to sculpt a 3-D shape, either real or abstract, which is then rendered and manipulated again in Photoshop.'
Jean-Pierre Braganza

opposite
JEAN-PIERRE BRAGANZA
Moonlight Disco
Photoshop, ZBrush

LEFT
JEAN-PIERRE BRAGANZA

Grey Skeleton
Photoshop, ZBrush

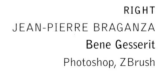

RIGHT
JEAN-PIERRE BRAGANZA
Bene Gesserit
Photoshop, ZBrush

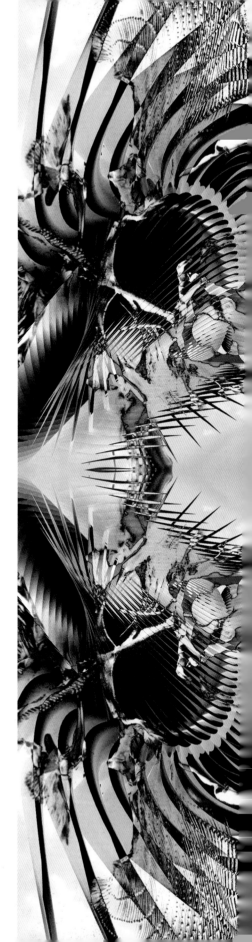

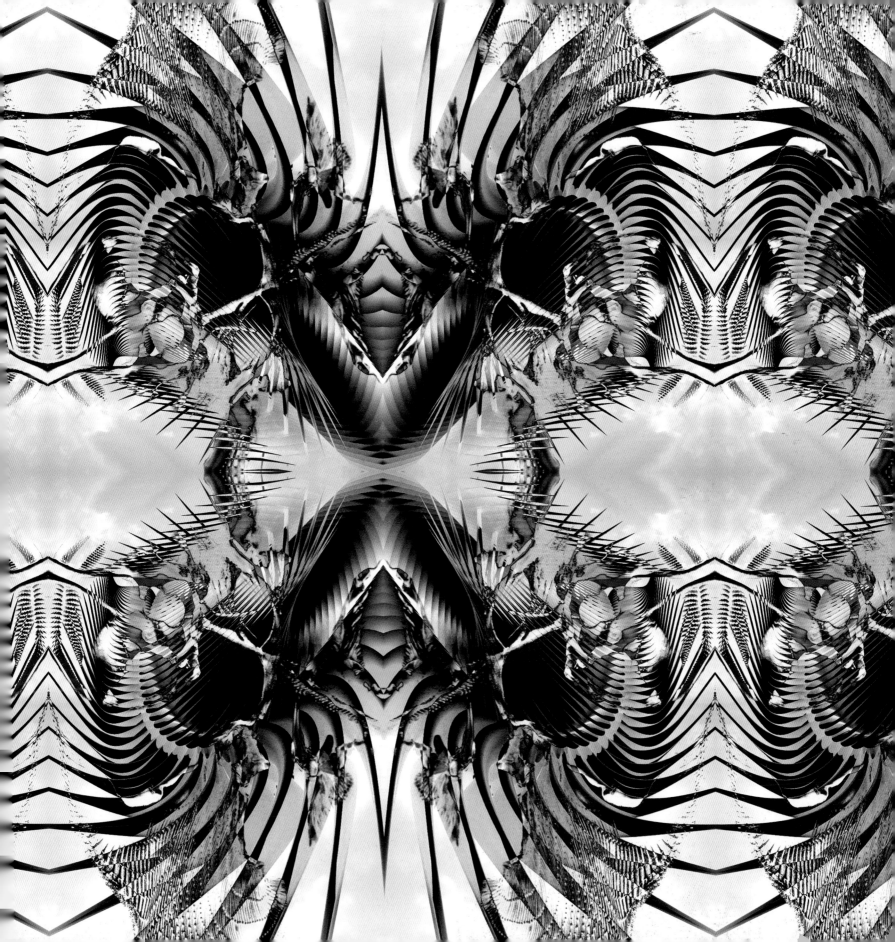

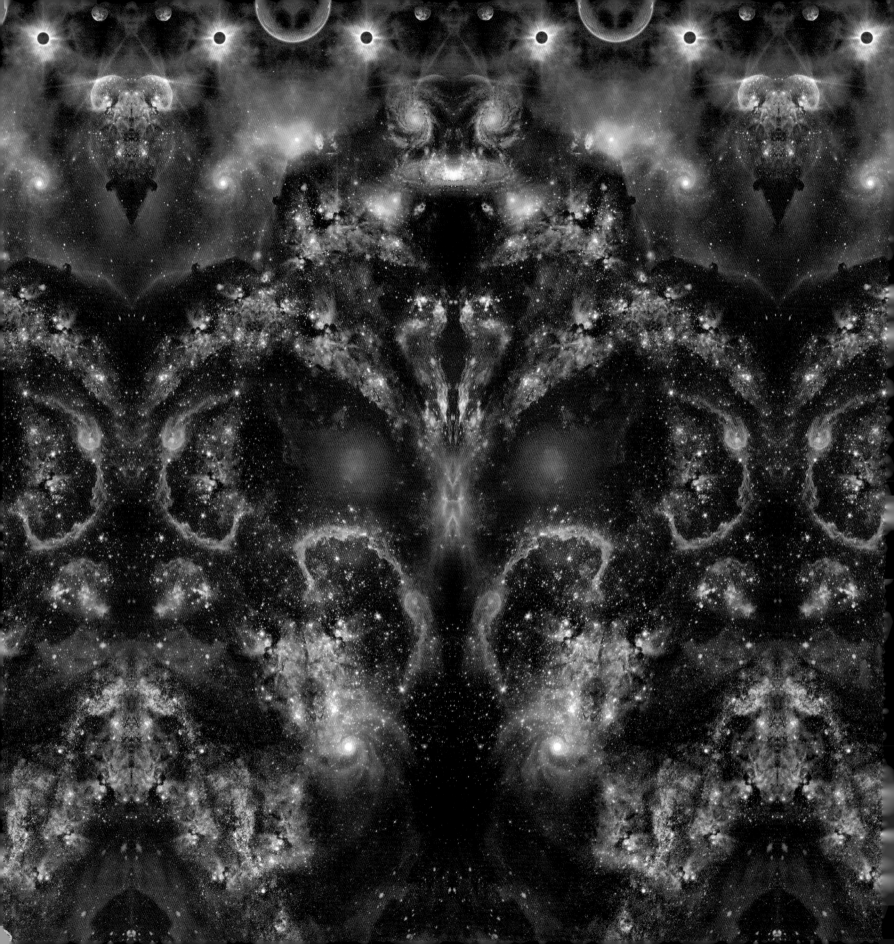

LEFT
CHANGBAE SEO
Cosmosprint v3
Photoshop

RIGHT
LEILA VIBERT-STOKES
Icescape
Pen, ink, gouache, Photoshop

Chapter 7
Tutorials

Introduction

Now that you have been inspired by the artwork showcased in the previous chapters, the time has come to get started with your own work. In contrast with my previous books, all tutorials have been gathered in one chapter. As I explained earlier in this book, this change reflects experience gained from teaching students using my books. The constant page-flicking to find the correct tutorial embedded within artwork sections drew me to the conclusion that gathering all the tutorials in one chapter was the best way forward. The tutorials are laid out in a logical and progressive way to help the reader navigate from source input to production output. Please note that some editing of the non-core skills has had to be made, and so not every possible scenario or print issue can be covered.

Print context

I invite the reader to think laterally when navigating through the tutorials, as being able to extrapolate some skills and transfer them to other areas is required to get the best out of these pages. Try to see within the tutorial what is applicable to your own needs and then tailor it to suit the print you are working on.

The speed of evolution and depth of knowledge now required in printing for fashion is something to be aware of; because of this, print studios tend to specialize in fashion prints for specific areas or cloth types. Realistically, most companies have very short creative cycles and time pressure is enormous for most fashion print designers. Prints constantly evolve and change during the in-house development process. This means that most efforts are usually spent on editing and refining a print on screen, which calls mainly for software-based skills. Usually developers will have to deal directly with factories or print houses regarding print techniques and technical issues. Your work scope for print can vary greatly, depending on the size of the company you work for. Generally speaking, the smaller the company, the more work scope you will need.

Developing a print tutorial by tutorial

The tutorials have been planned to follow the process of print development step by step. So we start with issues about importing source images and finish with preparing for output. Remember that as long as your print stays on screen you should focus on the creative aspects, but never lose sight of what the print technique is and the type of fabric you are going to print on. I have seen inexperienced designers discard a whole print either because the technique did not suit a fabric or because the artwork was not suitable for a particular technique.

The map below divides the tutorials into three sections: firstly, input, adjustment and selection; secondly, design development; thirdly, handover and output. The tutorials focus mainly on steps 5 and 9 of the full workflow chart shown on pages 12–13.

Tutorial 1

Scanning and lens correction

Photoshop

This tutorial looks at two common scenarios when importing source images in Photoshop: first, scanning large-format artwork; and second, correcting digital photographs with lens distortion. An example of the first issue might be the need to scan an A3-sized drawing on a classic A4 scanner; and for the second, let's assume that a designer has taken lots of quick snapshots on a research trip to flea markets and second-hand shops, and has one image that is of particular interest but which has lens deformation. Here we'll look at how to solve these problems.

Scanning large-format prints

1. Place the oversized print on the scanner bed, making sure that it is well aligned with the scanner's ruler edges. In Photoshop, go to File > Import > Select Your Listed Scanner (if it is not listed, scan from your scanner's own application). Press Preview and then, using the Marquee tool, select the whole scanning area. Select 300dpi in the Output menu. Finish by clicking on the Scan button. Repeat the process with the remaining portion of the oversized print. Make sure that you overlap the image to facilitate the merging later.

2. Create a new document at 300dpi and sized to match the artwork you are scanning (for example, A3 – 297 x 420mm). Drag the two sides of the artwork onto the new document.

3. Start by locking one of the layers to make sure that it doesn't move. Then align the other side over the top. To help you to see where it goes more clearly, try reducing the opacity in the Layers palette so that you can see the image underneath. Once placed, turn the opacity back up to see what it looks like. If needed, use the arrow on the keyboard for more precision.

4 If your artwork has a white edge, you might want to crop it. To do so, select the Crop tool (shortcut C) from the toolbox. Click and drag over the canvas – a box will appear with a dark border. Everything in the dark border will be cropped off the image.

5 To flatten your work, select both layers (press Shift to do so) in the Layers palette > right click > Merge Layers. You can also flatten the image completely (⌘ + Shift + E or Ctrl + Shift + E for Windows PC).

▪ Quick tips

- If you are struggling to place the image because it is 'snapping' into place, go to Menu > View > Snap and untick the option.

- Even if you have aligned both parts of the artwork with the scanner's ruler, you might still need to slightly rotate one half of the artwork to make it match perfectly with the other. When doing this, make sure that you move the Free Transform centre cursor on top of the portion of artwork that is well aligned, then input a small amount of rotation (for example, 1 per cent) in the Options palette.

Lens correction

1 Open your photograph in Photoshop. Go to Menu > Filter > Distort > Lens Correction (⌘ + Shift + R or Ctrl + Shift + R for Windows PC).

2 Once the Lens Correction window has opened, you can use the Auto Correction tab and enter your camera specification or click the Custom tab to alter the image manually.

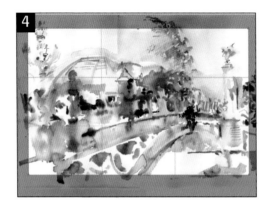

3 To straighten your picture, you can use the grid as a guide. Alter the size and colour of the grid so that it is most useful for your image. You can also move the grid around using the Move Grid tool (shortcut M) on the top left of the window.

4 Start by correcting the Geometric Distortion of your image. To do so, drag the cursor to the left to bloat the image or move it to the right to deflate the image. Note that most of the time only minor Geometric Distortion is necessary, depending on your camera's lens.

5 To remove the 'vignetting' (the darkened edges around the image), move the cursor to lighten or darken accordingly.

6 If your photograph has been taken at an angle, like in the example shown here, you can modify it using Vertical and Horizontal Perspective tools in the Transform menu. Photoshop CS5 will resize the image to fit your screen, ensuring that no transparent areas appear due to the reshaping.

7 If needed, you can rotate the image by moving the wheel in the Transform menu; this will change the angle. For more precision, type in the exact angle as the rotate wheel is quite sensitive.

3

4

5

6

■ Quick tip

You can alter your image in the Lens Correction menu manually by using the settings under the Custom tab or by using the tools on the left-hand side. On the right, the Auto Correction tab can be used; this is fast, but less precise.

The same image with Lens Correction applied to it

Tutorial 2

Adjusting and cleaning up imported artworks

Photoshop

If you want to do a job properly, you should always use the best tools available. So when you need to adjust a scanned drawing or any digital image, you should use Photoshop's Curves function. Curves gives you more control than Levels, allowing you to control any portion of grey tones more accurately. Curves might look daunting at first, but if they are used as Adjustment Layers, they remain fully editable and therefore give you more freedom to experiment. So let's have a look at how to get the best out of Photoshop's Curves when working from a hand-drawn sketch.

1 As explained in Tutorial 1, scan your original artwork. Don't worry about cleaning up the mess on your artwork with an eraser or white pen; simply place the image on your scanner, making sure that it is as straight and flat as possible.

2 Once your scanned image is open in Photoshop, go to Menu > Window > Adjustment. In the Adjustment palette (Earlier versions than CS4: use regular Curves), select the Curves icon (circled). Automatically, a new Curves Adjustment Layer is created in the Layers palette.

3 In the Adjustment palette, start by going into the Pop menu on the top-right corner and select Show Clipping for Black/White Points (this will reveal the pixels that are being 'clipped' – i.e., lost, as you modify the curve).

4 Usually, a drawing done with a pencil on white paper has grey smudges around the pencil strokes. To get rid of these, clip the white pixels by sliding the white marker to the left. You should see the clipped pixels appearing in bright tones.

5 Experiment with the curve by pressing and dragging it gently; usually, you should drag it below the line on the black side and above the line on the white side to get a more contrasted image with strong black and pure white. Try not to exaggerate your movements as this could result in an over-contrasted image with no remaining grey tones.

6 If you go too far, you can always reset the curves by clicking on the Reset icon on the Adjustment palette (circled).

7 The image should start to look more like a black pen drawing on pure white paper. You will not manage to get rid of all the stains, especially those closer to the thinner lines. To solve this problem, use the Eraser

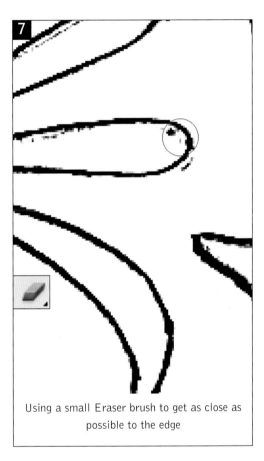

Using a small Eraser brush to get as close as possible to the edge

tool, making sure that your background colour is set to white to re-create pure white paper.

8 Use a smaller Eraser brush to get closer to the edges of your drawing, making sure that you get rid of only the stains and not your actual image. You can also use the Lasso tool to select around the illustration by 'lassoing' the stains away.

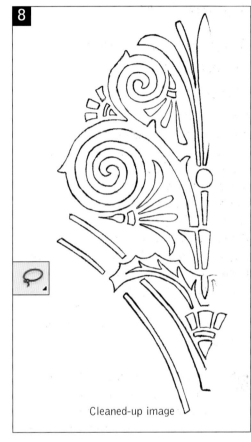

Cleaned-up image

9 Once you are happy with the result, you will have to flip the image if, like in the example shown here, you have drawn only one side for symmetry. To do this, make sure that your rulers are visible – go to Menu > View > Rulers (⌘ + R or Ctrl + R for Windows PC) – then click and drag on the ruler to pull out a guide, placing it at the exact centre of your image. Then erase everything overlapping the guide.

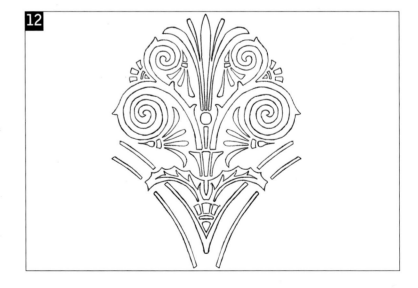

10 Use the Rectangular Marquee tool to select around your image, lining up the right edge of the rectangle to the centre guide. Then go to Menu > Layer > New > Layer Via Copy (⌘ + J or Ctrl + J for Windows PC), which will copy your selection onto a new layer.

11 Free transforming has many options, such as rescaling, distorting or rotating, but in this case you need to reflect your image. Go to Menu > Edit > Free Transform (⌘ + T or Ctrl + T for Windows PC) and once you see a box appear around the image, right click inside it and choose Reflect Horizontal.

12 Once the image is reflected, line it up to the other side, making sure that all points match exactly. For more precision, use the arrow keys on your keyboard.

Tutorial 3

Using the Path palette and Pen tool to select elements

Photoshop

More often than not, digital print designers will need to select specific elements within images when compositing a print. This process is important and knowing how to do it properly will certainly help your workflow. Forget the Magic Wand slapdash approach; most professional designers select objects using the Path palette and Pen tool. The technique featured here is certainly more labour-intensive, but putting a little extra effort into selecting elements from an image does pay dividends. Clean edges and smooth lines distinguish this way of selecting. The paths created with the Pen tool are fully editable, making this technique one of the most flexible and accurate available. In this tutorial we'll select and cut away a flower from a background to use as a print composition element.

1 Access the Path palette, which is found in Menu > Window > Paths.

2 Open an image from which you want to select an element. Make sure that the file is of good quality and not pixelated or blurry.

3 In the Path palette, click on the New Path icon (or the drop-down menu for more options), as highlighted.

4 In the toolbox, select the Pen tool.

5 Zoom in close so that you have a good view of the element's edge – try Menu > View > Actual Pixels (⌘ + 1 or Ctrl + 1 for Windows PC).

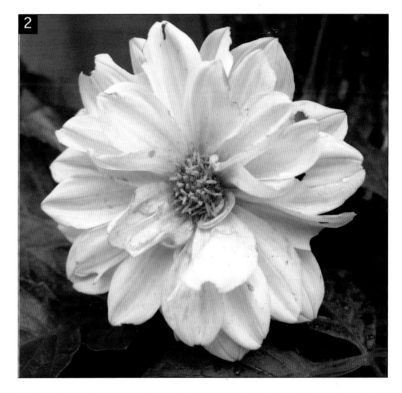

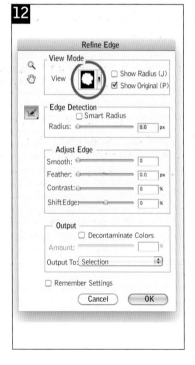

6 Place the first anchor point on the edge of the element, then move along the edge and place a second one.

7 Trace around the entire element, finishing where you started. The last anchor point should be placed exactly on top of the first one.

8 Use the Direct Selection tool to retouch any part of the path that does not fit well with the edge of the element.

9 You might need to subtract some parts from the main selection; if so, simply trace them within the path.

10 Make sure that Subtract from Path Area is selected in the Options palette (Menu > Window > Options).

11 In the Path palette, click on Load Path as a selection icon (this can also be accessed through the drop-down menu).

12 Go to Menu > Select > Refine Edge (⌘ + Alt + R or Ctrl + Alt + R for Windows PC). Under Adjust Edge (CS5), slide the Feather and Smooth control to create a nice edge finish. Under View (CS5), or the Preview icon in previous versions, select the right background option to suit your artwork – i.e., the background onto which you will place the element for a print. For example, if your destination background is dark, use the black Preview, etc.

13 Copy and paste the element – this will automatically create a new layer containing only the selected element.

14 The element is now ready to be composited in a print.

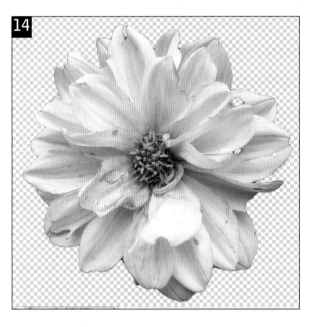

■ Quick tip

To select the edge of the element precisely, you should use a mixture of straight lines and curves, which are created as follows:

To create a straight line:
1. Click with the mouse to drop the first anchor point.
2. Move the mouse to the next point.
3. Click with the mouse.

To create a curve:
1. Click with the mouse to drop the first anchor point.
2. Move the mouse to the next point.
3. Press and drag the mouse to create a Bézier curve handle.

To create a straight line after a curve:
1. Click with the mouse to drop the first anchor point.
2. Move the mouse to the next point.
3. Press and drag the mouse to create a Bézier curve handle.
4. Alt + click on an anchor point to delete half the Bézier handle.
5. Move the mouse to the next point and click.

Tutorial 4

Using Smart Edges and the Quick Selection tool

Photoshop CS5

If you have done the previous tutorial, you will have noticed that most of the hard work is done manually. Well ... aren't computers supposed to do everything for us? Photoshop has evolved amazingly intuitive features. Quick Selection and Smart Edges are both very impressive and have now matured enough to be worth trying. The Quick Selection tool is great for rapidly selecting an object and Smart Edges is really good at dealing with very fine edges such as in feathers and hair (which would be really difficult to select manually). In this tutorial we'll be using both these tools: first, Quick Selection to select the edges roughly; and then Smart Edges to finish off the trickier feather edges.

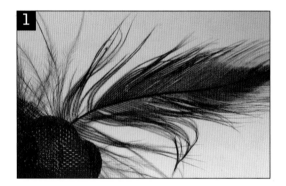

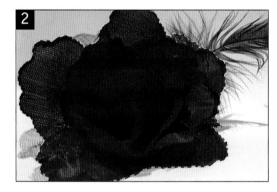

1 Start by finding a picture that has a plain background and a high resolution with good edge definition.

2 With the Quick Selection tool, press and drag inside the required element, going close to the edge to select. Try to do this swiftly; don't worry if the selection doesn't match the object perfectly.

3 By default, you can easily add to your first selection by pressing and dragging the mouse further. To take away from the selection, press the Alt key (on both Mac and PC) or tick on the Subtract from Selection icon in the Options palette. To capture the finer details (in this case, of the feather), try to use a smaller brush size.

4 After adding or subtracting from the selection you might still have big areas of the background merging with the selection. To avoid this, try to use a smaller brush and zoom in closer. If you still have difficulties, use the Lasso tool to select around the problematic edges quickly.

The very fine edges above cannot be selected easily

The edge is now roughly selected with the help of the Lasso tool

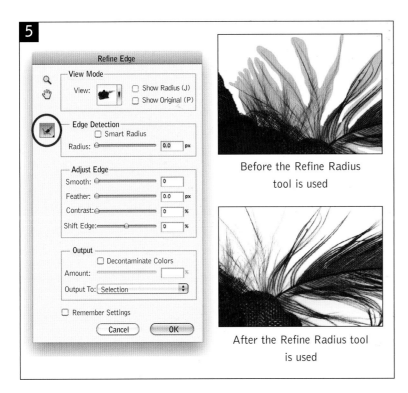

Before the Refine Radius
tool is used

After the Refine Radius tool
is used

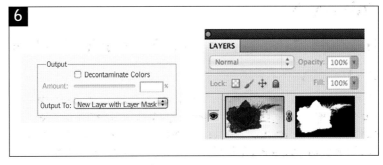

5 Now here comes the fun part! Go to Menu > Select > Refine Edge (⌘ + Alt + R or Ctrl + Alt + R for Windows PC). In the Refine Edge palette, select the Refine Radius tool and use this to brush over the areas that still have rough edges. The background should now be magically knocked away, while the thin feather 'hairs' remain. Carry on the process until you are happy with how the selection looks.

6 In the Refine Edge palette, before pressing OK, select Output to: New Layer with Mask. This will give you more flexibility in retouching the Layer Mask. If you need to retouch the mask, click on it in the layer and go to Menu > Select > Refine Mask.

7 The flower is now set against a solid colour background and retains most of its fine feather edges.

■ Quick tip

For a more accurate result, in the Refine Edge palette, select a different viewing mode, which reveals the original background better. Usually, if the original background is a light colour, you should opt for the black background, and vice versa. Keep on using the Refine Radius tool to clean up any edges that become visible in another viewing mode.

Tutorial 5

Using Photoshop filters

Photoshop

Some of you might balk at using filters in Photoshop: 'They look tacky' or 'It's the easy option' are the kinds of comments I often hear from disgruntled designers. Yet any savvy print designers knowing how to use filters in Photoshop effectively will be able to produce great print content swiftly and effortlessly. The key is to use filters in Photoshop lightly and to use several ones together, or to use them in conjunction with other effects to blur the trail to easy filter recognition. Photoshop filters are powerful and plentiful; they can be used for a variety of processes. This tutorial shows a few possibilities in a couple of mini-tutorials.

Using multiple effects in the Filter Gallery

This first mini-tutorial shows that all that lies between a quick snapshot of a market stall and great print content are a few filters.

1 Find a good object or subject that you want to use as print content. Since you will be using filters, the quality of the source material does not necessarily need to be high.

2 It is always good practice in Photoshop to duplicate the background layer so that you can revert to the original image if necessary. To do so, simply press and drag the background layer onto the New Layer icon in the Layers palette.

3 Go to Menu > Filter > Filter Gallery. Start by picking one filter and adjusting its parameters to achieve an interesting visual effect.

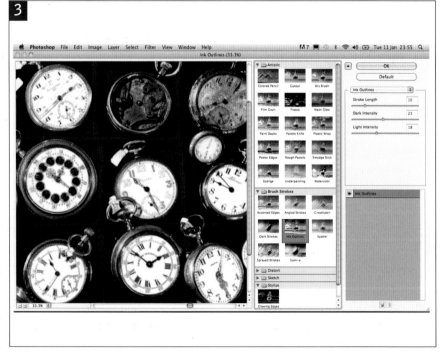

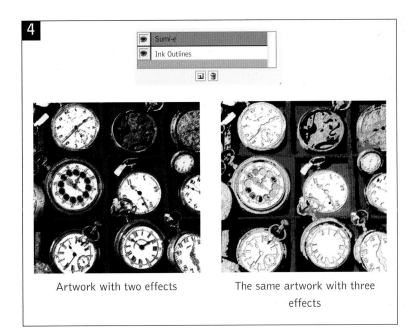

Artwork with two effects

The same artwork with three effects

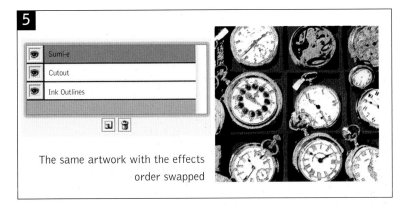

The same artwork with the effects order swapped

4 To avoid an instantly recognizable filter effect on your artwork, add more filters to the image. Do this by adding new Effect Layers.

5 Experiment with your artwork by pressing and dragging the Effect Layers into different positions. Finish the process by pressing OK.

Using filters in conjunction with image adjustments

Filters used alone have limited scope and control over colour. Adding colour adjustments to filters further enhances creativity.

1 Start by duplicating the background layer, as explained in step 2 in the first mini-tutorial (on the opposite page).

2 On the duplicated layer, use one of the colour adjustment functions, such as Hue/Saturation (⌘ + U or Ctrl + U for Windows PC). Note that in CS5 you can use presets such as Sepia in the palette's drop-down menu, which can be quite useful to achieve a certain look and feel quickly.

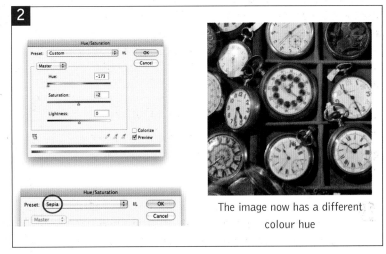

The image now has a different colour hue

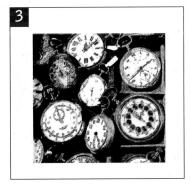

3 Following this, open the Filter Gallery again to apply filters as in the previous mini-tutorial.

Smart Filters

Smart Filters (from CS3 onwards) are non-destructive filters that can be re-edited, enabling designers to play around with variations and filter combinations. To apply Smart Filters, select a layer in your artwork and go to Menu > Filter > Convert for Smart Filters. Choose a filter from the Filter menu, set its options and press OK. You can add many filters and swap them around, as in the Filter Gallery. To edit the filter, simply double click on its instance in the Layers palette.

A Smart Filters layer with two filter instances (the Smart Object icon is circled in red)

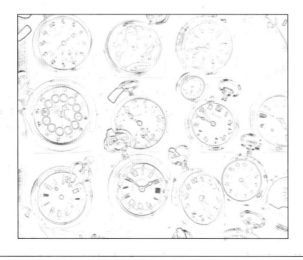

▮ Quick tip

One of the problems with Photoshop is that once a filter or adjustment has been applied and the file closed, you cannot edit or alter it again. However, if you use the Adjustment palette rather than Menu > Image > Adjustments, you can create editable layers.

The Adjustment palette. Each icon represents an adjustment mode

The Hue/Saturation palette in Adjustment Layer mode. Note the differences from the menu Adjustment palette used before: by selecting the Adjustment to Layer button on this palette (circled in red) the adjustment affects only the layer below it

An Adjustment Layer in the Layers palette, shown here (with the arrow icon circled in red) affecting only the layer directly below

Tutorial 6

Using Appearance, Effects and Graphic Styles

Illustrator

In Illustrator, filters are called Effects, the distinction being made because Effects are truly editable, unlike filters. When Effects, fill colours and strokes are applied to an object, Illustrator will duly list these components in the Appearance palette. Each one can be edited and customized as you see fit. Graphic Styles are preset collections of Effects, fill colours and strokes that can be applied to any object. These three elements constitute a very powerful package for changing the look and feel of your print elements quickly. Try out and experiment with all the different effects and Graphic Styles available; the possibilities are endless. First, let's create an object, and apply and edit effects onto it.

1 Create an object that has at least a fill colour or stroke and select it with the Selection tool (black arrow).

2 In the Appearance palette (Menu > Window > Appearance or Shift + F6), select one of the components listed (either a fill or a stroke), go to Menu > Effects and choose from one of the Illustrator effects (here we are working with 3-D > Extrude & Bevel Effect).

3 Tick on Preview to visualize how the effect affects your object, and More Options to play with 3-D lighting.

4 To edit an object's Appearance instantly, double click on its component in the Appearance palette. This will open the relevant window where you can update the effect as you wish.

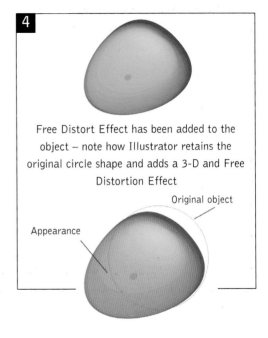

Free Distort Effect has been added to the object – note how Illustrator retains the original circle shape and adds a 3-D and Free Distortion Effect

Original object

Appearance

6

10

For this tutorial Neon Effects graphic styles were chosen

11

7

9

9 Start by drawing a shape for a print and colour it with at least a fill or a stroke.

10 To access the Graphic Styles palette, go to Menu > Window > Graphic Styles (Shift + F5). To access Graphic Styles Libraries, go to Menu > Window > Graphic Styles Libraries or the drop-down menu on the palette (circled in red).

11 To apply these styles, select your object and then select Graphic Styles.

5 To add an effect, repeat from step 1.

6 Quickly spawn the original object to develop the print, then cut and paste the original object (or drag while pressing the Alt key).

7 Then select each new object and add, edit, transform or delete effects from the Appearance palette.

8 For the second part of this tutorial we'll use Graphic Styles, edit them, and then add some Photoshop effects.

12 To add a Photoshop effect, select Add a Fill or Stroke in the Appearance palette (in the drop-down menu or at the bottom left of the palette). Select the component just added and go to Menu > Effects > Effects Gallery and

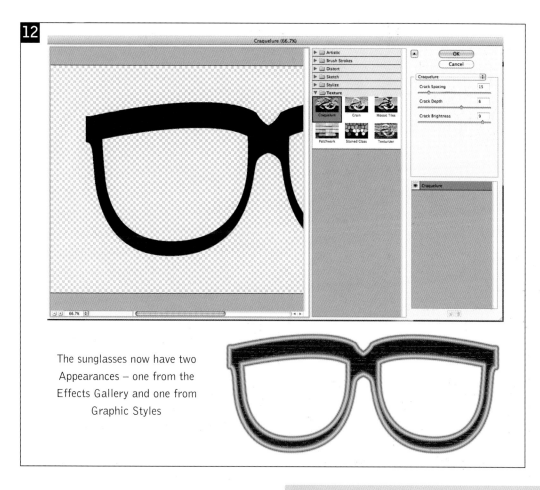

The sunglasses now have two
Appearances – one from the
Effects Gallery and one from
Graphic Styles

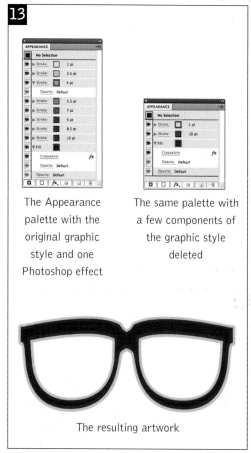

The Appearance
palette with the
original graphic
style and one
Photoshop effect

The same palette with
a few components of
the graphic style
deleted

The resulting artwork

choose an effect. Note how the
Illustrator Effects Gallery is very
similar to Photoshop's Filters Gallery.

13 Finish the artwork by customizing the
Neon Effect. Here this was done by
simply hiding or deleting some of the
components in the Appearance
palette.

■ **Quick tip**

It is always good practice to expand
an object's appearance (Menu >
Object > Expand Appearance) before
using it as a symbol (see Tutorial 14,
page 156).

The object used as a symbol

Tutorial 7

Working with Live Trace

Illustrator

A long time ago in a far, faraway world, Illustrator did not have Live Trace and that was pretty bad! On a more serious note, Live Trace converts any bitmap image into vector graphics. This is a really important feature for fashion print designers working in Illustrator with clip art and other source images to be included in print compositions. For this tutorial we'll look at the key features of Live Trace, working with a simple clip art image.

1 Open a bitmap image or clip art in Illustrator; avoid low-resolution clip art to ensure better results. Note that you can use Live Trace even if the image is placed rather than embedded on the document.

2 Select the image and go to Menu > Object > Live Trace > Tracing Options. Tick Preview to see real-time how changing the settings affects your image.

3 The Tracing Options window is divided into two main areas: Adjustments, which deals with the number of colours the Live Trace should include; and Trace Settings, which deals with how precisely the trace will follow the original image. Experiment with these settings to discover the best possible look and feel for your traced image.

4 If your image has white elements or a white background, select Ignore White to make the white sections transparent. Live Trace will draw a path around only the coloured areas. If you intend to fill colours in the white areas, untick Ignore White. Press Trace to confirm the tracing.

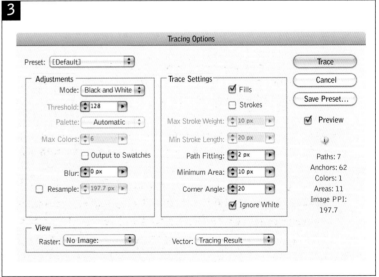

5 Follow this by pressing Expand in the Control panel. By doing this you are 'committing' (i.e., converting the bitmap image to vectors) so you might want to duplicate the image before expanding.

6 The traced image is always grouped, so go to Menu > Object > Ungroup (⌘ + Shift + G or Ctrl + Shift + G for Windows PC).

7 Finish by selecting the different areas of the traced image and replacing the colours if desired.

■ Quick tips

- In the Tracing Options window, if you hover over the drop-down menus displayed, a yellow box will appear describing what each setting does.

- For best results, try preparing your image in Photoshop beforehand, giving it clear edges and contrasting colours.

- When using Live Trace for colour images, in the Tracing Options window, with the mode set to Colour, try different numbers of colours. Fewer colours will reduce the details, although this can be used as a feature of the design.

Preset settings

If you are in a hurry, why not try using Illustrator's Live Trace preset settings? These can be found on the drop-down menu in the Control panel; their names are pretty self-explanatory and different settings will affect images differently. You can also save your own settings as a Preset, to be applied to later work.

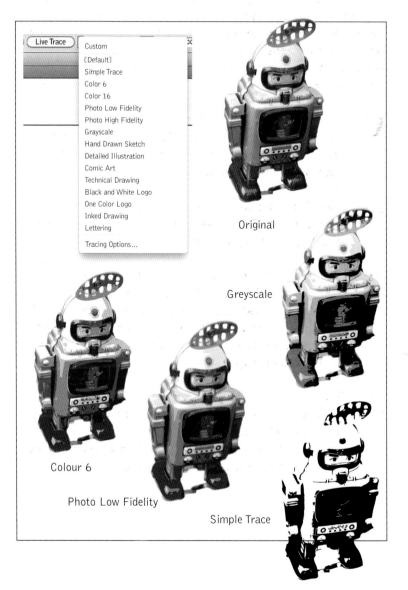

Original

Greyscale

Colour 6

Photo Low Fidelity

Simple Trace

Tutorial 8

Using Puppet Warp

Photoshop CS5

If there is one outstanding argument for upgrading to Photoshop CS5, it has to be the new Puppet Warp feature. This is especially so for fashion print designers since Puppet Warp can very convincingly distort any common element found in a print. As this tutorial shows, with one selected object you can create plenty of distorted versions and lay them out to create visually interesting repeat patterns. This is the first appearance of Puppet Warp and you can bet your bottom dollar that this feature will become even better in future Photoshop versions. So go on, jump in and try it out.

1 To get the best out of Puppet Warp, cut out the object you wish to distort (as shown in Tutorials 3 and 4).

2 Go to Menu > Edit > Puppet Warp. You will see a mesh appear over your object (which can be removed by unticking Show Mesh in the Control panel). Puppet Warp works with Pins, which should be placed where you wish to have a point of articulation, just like the human body's key joints. Click to place Pins on your object, remembering that each Pin interacts with the others (similar to how knees always move in relation to ankles and hips!), so think of positioning each Pin in relation to the next. Try to keep the Pin number low.

3 To start distorting the object, press and drag one of the Pins. Note how the rest of the object moves in relation to both the moved Pin and the other ones.

4 On the Control panel, change the mode to Distort, Rigid or Normal. Each mode interacts quite differently when a Pin is moved: the Rigid mode keeps most of the object rigid, bending only where the Pin is moved; Normal mode stretches the object like an elastic band; and Distort mode is like a magnifying lens. Try to experiment with each.

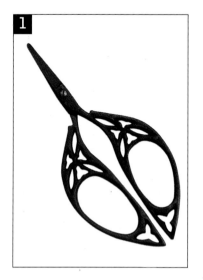

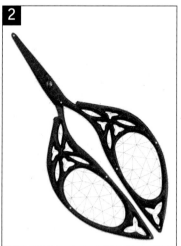

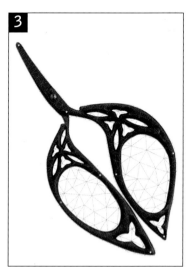

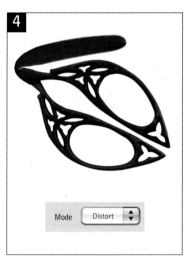

5 To edit a Pin further, select it (selected Pins have a black dot in the middle) and press Alt while hovering over it (but not right on top of it). You will see a circle appear around it and the cursor will turn into a double arrow. Click and move around the circle to rotate the image around the Pin. Press Enter to confirm the Puppet Warp.

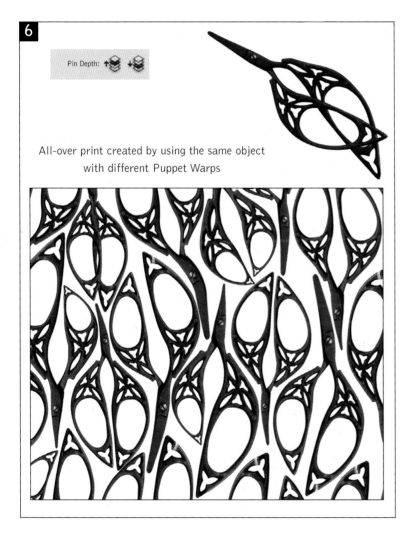

All-over print created by using the same object
with different Puppet Warps

6 Another feature of Puppet Warp is its ability to arrange the stacking order of an object's overlapping parts. For example, the two handles of the scissors shown above have overlapped. Puppet Warp can easily allow you to decide which side of the handle should be stacked on top. To do this, select a Pin located on the part you want to move to the front, go to Pin Depth on the Control panel, and click Set Pin Forward. To send a part to the back, click Set Pin Backward.

■ Quick tips

• You can still apply Photoshop Filters (see Tutorial 5, page 132) to Puppet Warp objects. These will be applied to match your warped image.

• If your image is on a normal layer, once Puppet Warp is confirmed you won't be able to edit it again at a later stage as previous Pins will have disappeared. By converting your layer into a Smart Layer (Menu > Filter > Convert for Smart Filters), the Puppet Warp will become a Smart Filter, meaning that you can double click it and edit it as many times as needed.

Tutorial 9

Compositing

Photoshop, Adobe Bridge

In the course of your print development you will usually need, at some point, to assemble all the different elements that comprise your print. Compositing is the crucible of creativity and mark-making: this is where it all happens; this is where good print composition comes alive. Photoshop is the best application for doing this, no question, and over the years it has evolved its arsenal of tools and functions to facilitate creativity and cater for designers' increasing requirements. This tutorial looks at how to get the best out of Photoshop's Layers, and uncovers a few tricks to help fashion print designers to produce great compositions.

Sourcing

1 Start by sourcing images to use for your composition, ensuring that all images are of similar quality and dpi size. Use Adobe Bridge to help with the selection of images.

2 Create a new document in Photoshop that is big enough to accommodate selected images and has space for experimenting with composition. Drag all images onto the new document. Make sure that each image or object has its own layer.

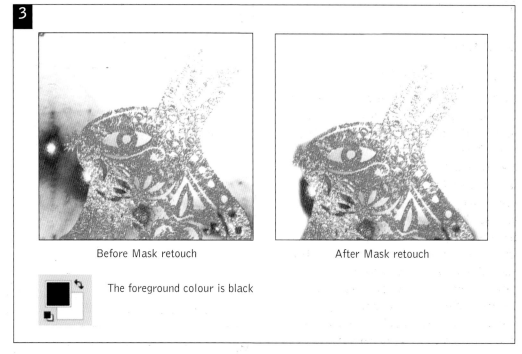

Before Mask retouch After Mask retouch

The foreground colour is black

Layer Masks

Layer Masks can hide portions of an image and can be easily edited by masking more in or less out. The best way to use Mask is by selecting the element or object you want to preserve, as explained in the selection tutorials (Tutorials 3 and 4, pages 127 and 130) or as shown here by using Colour Range selection. This is fast and works great with images that have a solid background colour.

1 Make sure that only the layer you are working on is visible (untick the Layer Visibility icon on all the others). Go to Menu > Select > Colour Range. With the Eyedropper, select the background colour and adjust the fuzziness to fine-tune the selection. Once done, Inverse the selection (⌘ + Shift + I or Ctrl + Shift + I for Windows PC).

2 Now click on the Mask icon in the Layers palette. Note how the Layer Mask is automatically created with the content of the selection.

3 To mask away more elements, click on the Mask icon in the layer to select it, then choose the Brush tool, making sure that the foreground colour is set to Black. On the canvas, paint the area you want to mask. If you want to remove masking, press X on the keyboard (this will give you a white foreground colour). Paint the mask away.

4 You can also create a blank mask by selecting a layer and clicking on the Mask icon without any selection. From there, mask only the elements you need to.

Composition

The key to successful composition is to experiment with different variations and combinations of the images. Don't think or try too hard; let yourself be guided by your hands and emotions!

1 Roughly compose the images on the canvas and use the Free Transform function (⌘ + T or Ctrl + T for Windows PC) to resize, rotate, skew, etc.

2 Work with the Layer Masks (as explained above) to start developing the interaction between the layers. Use the brush in the Layer Mask to remove unsightly elements (here the building's neon lights are mainly retained).

3 Reveal one layer of the rough composite at a time so that you work gradually into your composition and look at all the finer details.

4 You can add an Adjustment Layer to each layer to fine-tune the images in the composition further. Make sure that the adjustment affects only one layer (click on the Clip to Layer icon in the Adjustment palette).

5 If the composition contains many layers, it is a good idea to group them in folders containing key parts of the composition. Select the layers you want to keep in the same folder, click on the drop-down menu of the Layers palette, and choose New Group from Layers (⌘ + G or Ctrl + G for Windows PC).

Layer Blending mode

1 Blending modes determine how one image blends with an underlying image. Each Blending mode interacts differently, depending on both images' content and colours.

2 Select one layer and experiment with different Blending modes, found in the drop-down menu of the Layers palette.

1

▉ Quick tip

When compositing it is useful to work with a background that is the same colour as the textile you intend to print on. However, always make sure that you hide the background colour now and then to check that you have cleared all the remaining unsightly bits left over during the paint masking process.

Quick masking remnants might not be visible if the background colour is not hidden

2

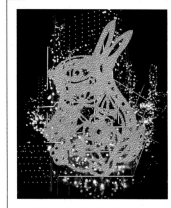

The rabbit with Normal (default) Blending mode

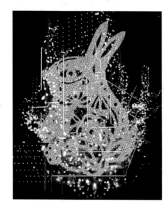

The rabbit with Lighten Blending mode

The rabbit with Linear Light Blending mode

The finished artwork with extra compositing

Tutorial 10

Using Live Paint

Illustrator

For years students had to painstakingly form closed objects in Illustrator to avoid bad fills, but then Live Paint came along to save more intuitive designers. With Live Paint you don't need to worry about how an object is constructed; as long as it looks as though it could be coloured in then it can be! Live Paint is a 'WYSIWYG' way to colour objects in Illustrator. It works, as in Photoshop, with the Live Paint Bucket tool, filling colour within areas delimited by a drawn border, regardless of the object's segments and anchor point construction.

Live Paint basics

1 If your image was scanned in or imported as a digital image, go to Tutorial 7 to create a Live Trace version of it. If it is a vector object, go to step 2. Here we are using the adjusted and cleaned-up artwork from Tutorial 2.

2 Select all the elements of the Live Traced or vector object to which you wish to apply Live Paint and then go to Window > Object > Live Paint > Make (⌘ + Alt + X or Ctrl + Alt + X for Windows PC).

3 Note how the bounding box of the Live Paint object has asterisk symbols in the corners.

4 To paint, select the Live Paint Bucket (K) from the toolbox and then select a fill colour. If you hover around the design, you will see that red lines appear. These indicate the area that will be filled; click to drop the colour in.

5 Paint each area of your design with your chosen colours, changing the colours of the Live Paint Bucket by selecting different fill colours in the Swatches palette.

6 To select various areas of your object simultaneously, use the Live Paint Selection tool (Shift + L). Click on the areas to be filled while pressing Shift. The areas selected will turn grey. Pick a colour from your swatches and it will be applied to all the selected areas.

Live Paint gaps

1 Nothing is perfect and even with Live Paint you might not be able to fill colour in a shape because Illustrator considers it to be an open shape with too big a gap. Here are a couple of ways to deal with this.

2 Select the Live Paint artwork and go to Menu > Object > Live Paint > Gap Options. In the palette, choose from the default gap sizes – either Small, Medium or Large. Make sure that Preview is ticked in order to see how Illustrator closes the gaps. If you are happy with the gaps detected by Illustrator, confirm by pressing the Close Gaps with Path button (this creates an invisible path to close gaps).

3 To close gaps manually, draw a line where you want to close a gap (as you would with a pen on paper). Select the drawn path and the Live Paint object, then go to Menu > Object > Live Paint > Merge.

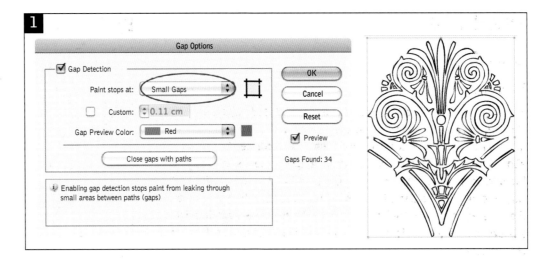

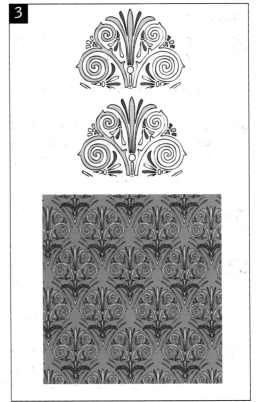

■ Quick tip

Some of Illustrator's features, such as gradient meshes or clipping masks, do not work on Live Paint objects. If you require these features, simply expand the artwork (Menu > Object > Live Paint > Expand). This will transform the object into a normal vector object with full features available.

Tutorial 11

Creating basic pattern tiles

Illustrator

Illustrator is probably the most commonly used software in fashion print design studios; its ubiquity and affordability have pushed away the competition. A simple reason for its popularity is the ease with which pattern tiles (or pattern swatches as they are referred to in Illustrator) can be created in this application compared to other, dedicated high-level software. In this tutorial we'll start with the basic pattern tile technique to introduce the way in which Illustrator works with tiles. We'll look at how to develop simple stripes, gradient stripes, polka dots and plaids, using various methods.

Simple stripes

1 To create a simple stripe, start by selecting the Rectangle tool (shortcut M) and single clicking anywhere on your artboard. Select the height (making sure that it is a round number) and the width of your rectangle, and press OK.

2 Choose a fill colour for the rectangle and make sure that it has no stroke.

3 Select the rectangle and right click > Transform > Move (Shift + ⌘ + M or Shift + Ctrl + M for Windows PC). Type in the height of your rectangle in the Vertical Position option and 0 cm for the Horizontal Position. Click Preview to make sure that the second rectangle is flush with the first one and then click Copy. Choose a different fill colour for the second rectangle.

4 Select both stripes and drag them into the Swatches menu (Menu > Window > Swatches). You will now see your stripes appear as a pattern tile. Draw a shape and select the new pattern tile as a fill colour to transform it into an all-over print.

Gradient stripes

1 Draw a new rectangle. Select it and go to Menu > Object > Transform > Transform Each (Alt + Shift + ⌘ + D or Alt + Shift + Ctrl + D for Windows PC).

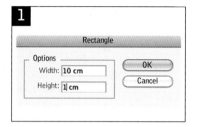

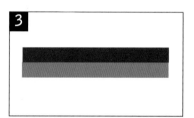

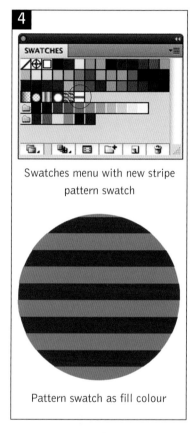

Swatches menu with new stripe pattern swatch

Pattern swatch as fill colour

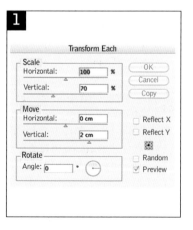

Preview of Vertical Scale and Vertical Move

2 Set the new Vertical Scale (making sure that it is under 100 per cent) and a Vertical Move distance. Preview to ensure that you are happy with the size and distance, and then click Copy.

3 For the next, thinner stripe, go to Menu > Object > Transform Again (⌘ + D or Ctrl + D for Windows PC). This repeats your last action, copying and scaling the stripe.

4 To turn the stripe into a pattern tile, follow step 4 above (simple stripes).

Polka dots – step repeat pattern 1

1 Start by drawing a square with a fill colour and no stroke. Make sure that the height/width is a round number (for example, 3 x 3 cm).

2 Draw a circle with a different fill colour and no stroke. Align it with the exact centre of the square, using the Align buttons on the Control panel.

3 Select both the circle and the square > right click > Transform > Move (Shift + ⌘ + M or Shift + Ctrl + M for Windows PC). Type in the height/width of your square in the Horizontal Position option and 0 cm for the Vertical Position. Click Copy.

4 Repeat the previous step by selecting and moving both shapes. This time, type in the height/width of your square in the Vertical Position option and 0 cm for the Horizontal Position.

5 You should now have a shape resembling a dice with the number 4 showing. Delete the top-left dot and the bottom-right one.

6 Select and drag all the shapes into the Swatches palette to create a new pattern tile.

Plaid – repeat pattern 2

1. Draw a square for your background colour (for example, 10 x 10 cm). Make sure that it has no stroke.

2. Draw a rectangle 10 cm high and however wide you want it. Place it towards the left of your background square and align it with the top.

3. Move (Shift + ⌘ + M or Shift + Ctrl + M for Windows PC). Make sure that you click Copy. Transform Again (⌘ + D or Ctrl + D for Windows PC), as before. Delete any overlapping rectangles.

4. Repeat the last step on the horizontal lines.

5. To make your plaid more interesting, you can add thinner lines in different colours or use Blending modes (see Tutorial 9).

6. To ensure that the tile will be seamless, make sure that the space between the plaid lines and the edges are evenly distributed on the left and right edge as well as on the top and bottom edge. Finish by dragging your work into the Swatches palette.

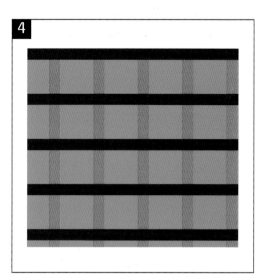

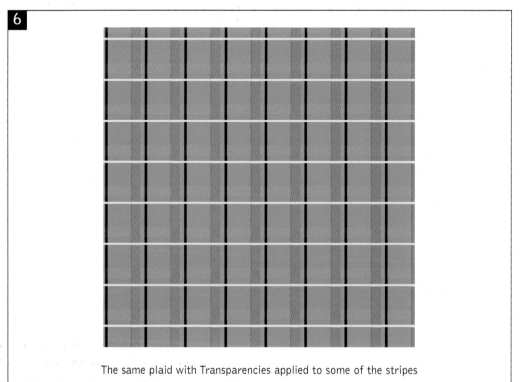

The same plaid with Transparencies applied to some of the stripes

Step repeat pattern 3

1 Make a square with a fill colour of your choice for the background. Place your print object outside the box on the top left.

2 Select your object and go to Menu > Object > Transform > Transform Each (Alt + Shift + ⌘ + D or Alt + Shift + Ctrl + D for Windows PC). Set and remember the horizontal distance by which you want to move your object and the angle to which you want it to rotate. Click Copy. Transform Again (⌘ + D or Ctrl + D for Windows PC) until the objects fill your background square. Delete any overlapping objects.

3 Select the first row, taking care not to select the background square. Repeat the Transform Each action, changing the vertical distance to the same amount as the horizontal distance in step 2 and setting the horizontal distance to 0 cm. Transform Again (⌘ + D or Ctrl + D for Windows PC), as before. Delete any overlapping objects.

4 Finish by making sure that the distance between the edges and the object is exactly half of the distance you gave in step 2. This will ensure that your tile is seamless.

If your background box looks too big, resize it by clicking and dragging the corner

■ Quick tips

• Rather than trying to develop a pattern at a difficult angle (for example, a 45-degree line), in Illustrator you can rotate the pattern swatch to any angle you require. To do this, select a shape you have filled and double click on the Rotate button in the toolbox. Choose an angle, untick Object and tick the Pattern box. Transform Again (⌘ + D or Ctrl + D for Windows PC) to repeat the rotation.

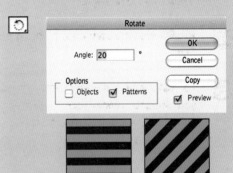

• To scale your pattern, select your shape and double click on the Scale button in the toolbox. Set the scale to 90 per cent or 110 per cent, untick Object and tick the Pattern box. Transform Again (⌘ + D or Ctrl + D for Windows PC) to keep scaling up or down.

Tutorial 12

Pattern tiles (intermediate)

Illustrator

Now that you have mastered basic pattern tiles in Illustrator, let's crank the skill level up a bit and look at tiles that require more advanced techniques to make a seamless repeat. The key skill here is to use a bounding box with no fill and stroke colour, which will define the edges of the tile and let the elements of the print spill over the border. Illustrator reads the edges of a pattern swatch either as the bounding box of objects selected for a swatch or the no-fill no-stroke rectangle, which must always be sent to the back of the stacking order.

1. Using the Rectangle tool, create a background square or rectangle with nice round numbers for the height and width. It is a good idea to lock the background square to make sure that it doesn't move during the print layout process (⌘ + 2 or Ctrl + 2 for Windows PC).

2. Place the print objects on top of the background square, overlapping them only on the top and left edges (make sure that no object is on both the top and left edges at the same time).

3. To add depth to the print, use a Blending mode between the background and some of the butterflies. To do this, select the

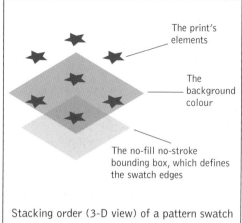

The print's elements

The background colour

The no-fill no-stroke bounding box, which defines the swatch edges

Stacking order (3-D view) of a pattern swatch

objects and the background square, then in the Transparency palette, select a Blending mode that suits your style.

4. Select all the objects overlapping the left edge, then select Move (⌘ + Shift + M or Ctrl + Shift + M for Windows PC) and input the square's width in the horizontal field to move the object to the right edge. Press Copy.

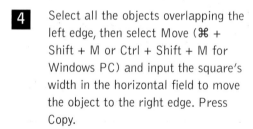

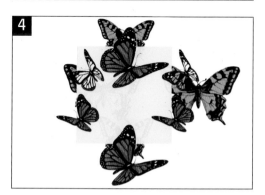

5. Do the same for the objects overlapping the top edge and copy them vertically to the bottom edge.

6. You can now fill in the gaps by adding more objects to the rest of the square, making sure that none of them spills over the background square's edges. Try to balance the pattern swatch, the objects and the background visually, and avoid large empty areas or overcrowded ones.

7 As explained in the introduction, you now need to tell Illustrator where the edge of the pattern tile is by creating a rectangle without stroke or fill. First, release the locked background box if necessary (⌘ + Alt + 2 or Ctrl + Alt + 2 for Windows PC), then copy it and Paste in Back (⌘ + B or Ctrl + B for Windows PC). Without deselecting, give it no fill and no stroke.

8 To ensure accuracy, you can now select and enlarge the coloured background square as the bounding box is setting the tile limits. Press Alt while resizing it to enlarge it from the centre.

9 Select all the swatch elements and drag them to the Swatches palette.

10 Try the all-over print by creating a large rectangle into which you apply your new pattern swatch.

Troubleshooting

A. The pattern swatch does not repeat seamlessly: When applied, the all-over print has a white border, repeating the whole image instead of the tile. Make sure that the bounding box is placed at the very back and has no fill and stroke. Use the Menu > Arrange > Send to Back function (⌘ + Shift + [or Ctrl + Shift + [for Windows PC).

B. The objects are not repeating seamlessly: this means that objects have not been copied properly as in steps 4 and 5 above. Try deleting the problematic object and copying it again. Make sure that you have copied ALL the overlapping objects.

Some of the objects seem to be chopped in half or the repeat is not seamless

■ Quick tip

One of the great advantages of Illustrator is that it can handle bitmap images as well as vector graphics, meaning that you can use both kinds to create a swatch for a print. Open your image in Illustrator and use it like any other object. Note that images have to be embedded in the document to be used as a swatch.

Bitmap images can be used in pattern swatches, and can also have effects, such as Drop Shadow, added

Tutorial 13

Pattern tiles (advanced)

Illustrator

So far, the pattern tiles we have dealt with have been pretty straightforward, from a one-dimensional repeat (stripes) to a two-dimensional repeat (vertical and horizontal). For this advanced tutorial, we'll look at working from source images that have an incomplete or non-existent repeat pattern – a typical scenario for design studios seeking inspiration from vintage prints. The main challenge here is to complete the gaps and create a fluid repeat pattern.

1 Make a Live Trace of your scanned fabric or source image (see Tutorial 7).

2 Place a horizontal and a vertical guide at the top and left of your Live Traced artwork where you feel the pattern should start and where it has good repeat elements.

3 Draw a rectangle from the two guides going down and right up to where you think the pattern should repeat (give yourself a bit of space between the end of the Live Trace and the repeat). Check the box dimensions in the Control panel; round up the numbers so they are easy to remember. Send the box to the back to make it transparent and lock it (⌘ + 2 or Ctrl + 2 for Windows PC). Select all the

objects overlapping the top guide and change the fill colour to help you to keep track and distinguish them from other objects. Make sure that no object is overlapping a corner.

4 Move (Shift + ⌘ + M or Shift + Ctrl + M for Windows PC) the objects downwards by the same amount as the box height. Click on Copy.

5 Delete any cropped objects and move aside any shapes that overlap for later use. Keep only the ones that have been moved down.

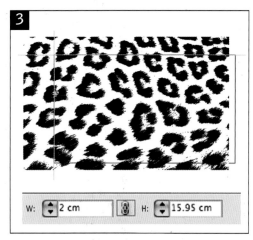

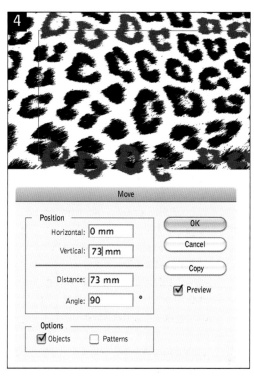

6 Repeat steps 4 to 6 on the vertical edge.

7 There are obvious gaps and tight spots on the print here that need to be corrected. Try to move the shapes that are not overlapping the edges first. You could possibly reintroduce the shapes that you set aside before to fill the gaps.

8 You might need to alter the repeat edge lines; if you do, make sure that what you change on one edge is duplicated on the other one. To work faster, select objects on both edges and shift them around using the arrow keys on the keyboard.

9 Depending on the artwork style, you might need to draw any missing bits manually. If not, copy and paste existing shapes and modify them to avoid easy-to-spot repetitions.

10 To fill visual gaps further, try to use the Effects > Free Distort tool, with which you can stretch existing shapes into gaps.

11 Drag your artwork into the Swatches palette, keeping the contrasting colours for the time being in order to spot potential problem areas.

12 Adjust the colours for a final check-up.

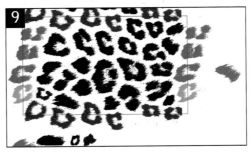

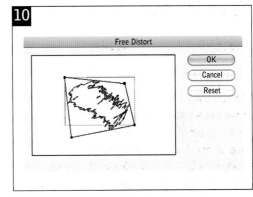

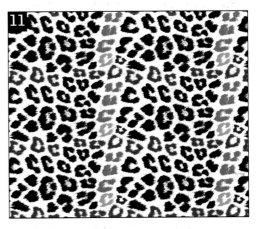

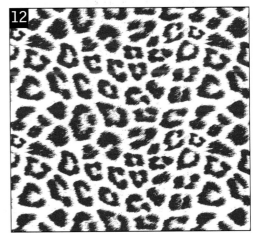

Tutorial 14

Working with symbols

Illustrator

Symbols are predesigned objects, which can be multiplied on a document as linked instances rather than original complex vector artworks, thus saving on time and file size. Illustrator has several Symbol libraries that can be used to develop prints, but generally it is a good idea to edit them to add a personal touch. In this tutorial we'll use a library symbol, transform it, and 'spray' it on the artboard to create a print design.

1 Open the Symbols palette (Menu > Window > Symbols), then in the palette's drop-down menu, select a Symbol Library.

2 Drag a chosen symbol onto the artboard, then either go to Menu > Object > Expand or in CS5 click on Edit Symbol in the Control panel. Edit the symbol by changing its shape or colour, etc.

3 You can also make your own symbols by drawing them on your artboard and dragging them into the Symbols palette. In the Symbol Options dialog box, simply press OK.

4 Select the Symbol Sprayer tool in the toolbox (Shift + S). Press and drag around to 'spray' the symbol.

5 For a more intuitive and customized spraying, double click on the Symbol Sprayer tool, then in the Symbolism Tools Options dialog box, set Scrunch, Size and Spin to User Defined. Now the spraying will follow your mouse movement closely (select Pressure under Intensity if you use a graphics tablet). Set the Diameter and Symbol Set Density for further customization.

6 Once you've finished the spraying, reposition, scale and rotate the symbol instances using the relevant tools (see above). It is a good idea

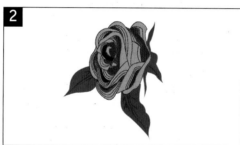

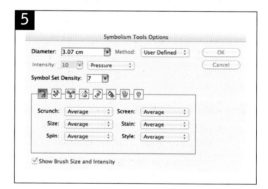

to tear off the Symbol Sprayer toolbox menu to allow you to change tools easily.

7 **Symbol Spinner:** click it and drag over the symbols you have sprayed. You will see a blue arrow appear – this indicates the direction in which the symbols will rotate. To rotate fewer of them at a time, change the Diameter in the Symbolism Tools Options dialog box.

8 **Symbol Sizer:** this rescales the symbols within your artwork. Click and drag over the symbols; the ones that are highlighted in blue will have the resizing applied to them. To make a specific cluster of symbols bigger, keep the Symbol Sizer clicked over them. Press Alt while clicking to make the symbols smaller.

9 **Symbol Shifter:** this allows you to move symbols around. You can also send them to the back by pressing Shift + Alt while clicking, or bring them to the front by pressing Shift.

10 **Symbol Scruncher:** this allows you to cluster symbols together or space them out (by pressing Alt while clicking). The blue guidelines that appear help you to preview where the symbols will go.

11 Beyond moving around and scaling Symbols, the following three tools add Appearance and effects:

12 **Symbol Stainer:** select a colour and drag the Stainer tool over your symbols. You can alter the intensity of the colour in the Symbolism Tools Options dialog box. You can also set it to Stylus, meaning that the intensity of the colour is determined by the pressure on your graphics tablet.

13 **Symbol Screener:** this alters the transparency of your symbols. It is especially useful if your symbols are overlapping each other. Press Alt to decrease transparency.

14 **Symbol Styler:** this tool applies graphic styles to your symbols. Set the tool to User Defined in the Symbolism Tools Options dialog box so that you can choose which graphic style should be applied to your symbols. Note that if you have sprayed a lot of symbols, applying the graphic style can be quite slow.

15 Once you are happy with your artwork, duplicate it and then expand it (Menu > Object > Expand) so that you can do any detailed retouching or compose it into a repeat pattern.

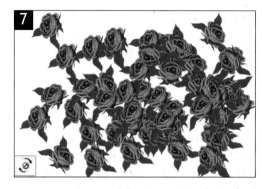

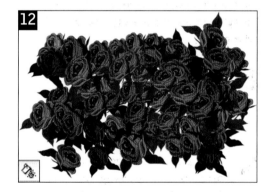

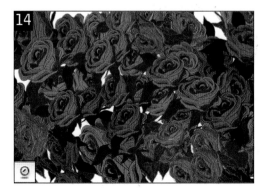

Tutorial 15

Using Art, Bristle and Scatter brushes

Illustrator

Illustrator's Art, Bristle and Scatter brushes are made up of anchor points and segments like any other vector objects, but have the added appearance of a brush stroke. Art, Bristle and Scatter brushes are fully editable so designers can play around, editing brushes endlessly, to achieve the best possible look and feel. Illustrator contains several Brush libraries, but it is also possible to create your own brush from scratch.

Art brushes

1 If you intend to create a pattern tile, start by creating a square with a background colour. If you want to create a placement print, go to step 2.

2 Go to Menu > Window > Brushes (shortcut F5) to bring up the Brushes menu.

3 The brushes that appear on the floating palette are the default Illustrator brushes. To open Brush Libraries, go to Menu > Window > Brush Libraries or click on the drop-down menu of the floating palette. Here you will find different brushes as well as different textures.

4 Select the brush from the Tools panel (shortcut B), then press and drag on the canvas. This will create a path to which the brush style will be applied.

5 Experiment with different brushes and sizes to find out what works for you. To change the size of a brush, alter

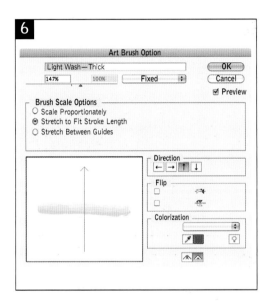

6

the stroke size in the Control panel; to change the colour of the brush, choose a colour for the stroke. You can also go back to previously drawn brush strokes to edit them.

6 Illustrator CS5 provides a new Profile feature, which enables you to change the overall brush profile within a stroke. The default profile is called Uniform; other profiles can be accessed through the Control panel. To edit a brush stroke further, double click on the Brush instance in the Brushes panel. This will bring up Art Brush Options. If you are using a graphics tablet, select Pressure under Width to provide a more life-like painting experience.

Bristle Brush (CS5 only)

This is Illustrator's latest attempt to marry the look and feel of a natural-media brush stroke with the editability of vector graphics.

1 Using the same artwork, open Brush Libraries and choose a Bristle Brush. Paint a stroke with it.

2 Next, double click the Bristle Brush in the Brushes panel to access the Bristle Brush Options menu. Customize the brush by changing settings such as Bristle Length, Density, Thickness or Paint Opacity (lower this to add depth). Click Preview to see how this affects the stroke previously painted.

Scatter brushes

The last type of brushes used on this artwork are Scatter brushes, which scatter a pattern along a path.

1 To view the Scatter brushes available, go to Menu > Window > Brush Libraries > Decorative > Decorative Scatter.

2 Use and edit these brushes in the same way as the others, remembering to double click on the Brush instance in the Brushes panel to change their settings further.

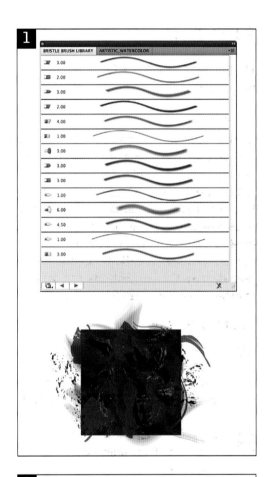

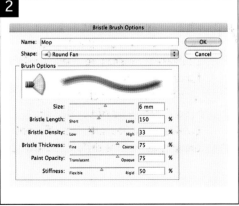

Creating your own Scatter or Art brush

1 Draw a shape on the artboard, select and drag it into the Brushes panel, choose Scatter Brush (or Art Brush) and press OK.

2 If you double click on the brush you have just created, you will see the Scatter Brush Options dialog box. Here you can edit every aspect of your new brush. Choose Random (or Pressure if you work with a graphics tablet) from the drop-down menu and move the Threshold Percentages cursors around. To change the colours, make sure that the Colourization Method drop-down menu is set to Hue Shift.

3 Experiment with your new brush to make sure that you are happy with the result. You can always apply new changes to brush strokes you have made previously.

▪ Quick tips

- Brushes can also be applied directly onto shapes, so rather than brushing the artwork freehand, you can draw it with the Pen tool for more precision, then apply a brush effect to the path.

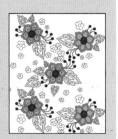

- All brushes created in Illustrator can have their Appearance expanded (Menu > Object > Expand Appearance). This can facilitate the file rendering (expanded objects are lighter in file size) or help when doing close-range edits. Note that once expanded, the brush stroke path disappears, thus making it impossible to edit again.

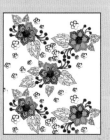

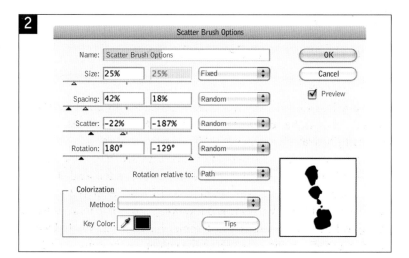

Artwork: Lena Karlsson, Faded

Tutorial 16

Using Brushes and Bristle Brushes

Photoshop (CS5)

In the previous tutorial we introduced Illustrator's Bristle Brushes; now let's look at the real deal – Photoshop's Bristle Brushes. Although Illustrator wins the editability battle hands down, Photoshop easily takes the lead in life-like brushes. One of the key features of Bristle Brushes is the level of customization available, covering anything from bristle length and stiffness to angle and shape. In this tutorial we'll focus on working with the Bristle Brushes setting while using the Mixer Brush tool, which enables you to blend a colour already on the canvas with the colour on the brush, much like working with natural paint media. For best results, use a graphics tablet.

1 Open your source image in Photoshop. Make sure that it has the tones of your chosen colour palette. Unless it is part of the design, try to use an image with as few dark colours as possible as these can be overpowering when blended together.

2 Create a new layer and open Menu > Window > Brush (shortcut F5).

3 Pick a Bristle Brush to work with. In the Brushes palette, set the parameters of your Bristle Brush – bristle length, stiffness, etc.

4 When a Bristle Brush is selected an image of a brush will appear on the top left of your artboard; this is a cross section of your brush and it will alter according to your settings. It will also move when you are painting to show you how the bristles interact.

5 Now select the Mixer Brush tool in the Tools palette. Look at the Options bar and make sure that you change the brush setting to 100 per cent Wet and 100 per cent Mix. Also

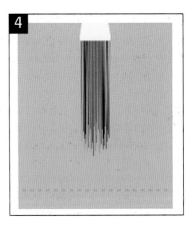

ensure that the Sample All Layers box is ticked as this will allow you to blend colours from the background image.

6 Start to paint some strokes, making sure that you are doing so on the new layer, to experiment with the brush and to see how the strokes react to your colours. The intensity of your brush will be determined by the pressure on your graphics tablet.

7 For a more instant effect, choose a large brush size. The size of your brush can be changed in the Brushes window or by right clicking anywhere on your artboard when the Brush tool is selected.

8 The blending brushes in CS5 work like real brushes; if you paint on one colour, the brush will be 'stained' when you paint on the next colour. You can use this in your design, or you can clean your brush by going to the Colour drop-down menu in the Options palette and selecting Clean Brush. Alternatively, click the Clean Brush After Each Stroke button. If you have a foreground colour in your Tools palette, this will blend with the background colour unless you untick Load Brush After Each Stroke in the Options palette.

9 Bristle Brushes offer a more interactive way of painting. You can change settings, such as the length, thickness and stiffness of the bristles, in the Brushes menu. These can significantly alter the outcome of your work. If you like a particular brush you have edited and will want to use again, go to the drop-down menu in the Brushes window and click on New Brush Preset.

10 To paint with normal brushes without the colours blending, untick the Sample All Layers option and make sure the Mix setting is at a low percentage. This will apply brush strokes in the colour you have loaded in the Options palette.

11 Try combining different brush types with each other to achieve a more interesting effect.

Clean Brush After Each Stroke
selected

Clean Brush After Each Stroke
not selected

■ Quick tips

- Use a brush with long bristles to create patterns by pressing and turning your stylus. This will make original shapes that don't necessarily resemble brush strokes.

- Even if the History palette enables you to go back in time, it is always recommended to Save As your file when you have reached key stages in your print development.

Tutorial 17

Creating a swatch book

Illustrator
Acrobat Pro

The dialogue between print designers and product managers or decision makers will involve a selection process on which prints are approved and which aren't. As a fashion print designer, you will be expected to deliver plenty of options to choose from. A swatch book should contain prints that are not fully formed but which are developed enough to enable you to communicate your ideas swiftly, and in most cases it should act as a sign-off document from which you can fully develop the selected prints (between steps 7 and 8 of the workflow chart on pages 12–13). This tutorial looks in detail at how to use Adobe Acrobat Pro to create and deliver a swatch book. Among many advantages, Acrobat Pro enables you to copy or password-protect your artwork (invaluable if you are a freelancer working with new, untested clients) and to output swatch books in any resolution required (for sending by email, etc.). Let's look at how best to create a swatch book using Adobe Acrobat Pro.

1 In Illustrator, create a new document with the dimensions you want your swatch book to be (usually A4 or A3).

2 Make a layout grid of your swatch book page. Make sure that you include important information such as print name, print code, season, sign-off box, etc.

3 Lock the layout grid layer and create a new layer on top. It is a good idea to make text boxes on this new layer so that you can easily fill in information later. Save in Illustrator Template (.ait) format and close the document. If you need to edit the grid later on, make the necessary changes and Save As Illustrator Template again, giving it the same file name and replacing the existing document.

4 Reopen the document. Copy and paste or place all the required print information and images into the Template file. Also, fill in relevant information in the text boxes you created on the grid.

5 If you are presenting an all-over print, make sure that you include a tile of your pattern swatch with its measurements. If it is not to scale, ensure that you state this. If your work is a placement print, include a full-scale version of it with precise measurements.

6 It is important to include a swatch of your print to scale even if it is cropped or some of the elements are missing. This will help your client, manager or buyer to understand the real proportions of the print.

7 Prepare all the information for each print in separate Illustrator files, always using your Template document to begin with and saving each one in Illustrator format.

Making a PDF

1 Once all your pages are ready as separate files, open Adobe Acrobat Pro and go to Menu > File > Create PDF > From Multiple Pages.

2 Browse to find the pages of your swatch book. After selecting all your pages, select Smaller File Size (if you want to email the swatch book) at the bottom right of the window. Click Create.

3 Once the PDF is created and saved, it will open automatically.

4 By default, Acrobat Pro lists each file alphabetically. To rearrange the pages, go to the panel to the left of the document window and click on the Pages button. Press and drag your pages into the right order.

1

Adobe Acrobat
Pro icon

2

If you cannot see the Pages button in the panel, go to Menu > View > Navigation Panels > Pages and make sure that Pages is ticked.

4

View settings

If you want your recipient to have specific view settings (for example, so that the file opens in full screen), do as follows:

1 Go to Menu > File > Properties (⌘ + D or Ctrl + D for Windows PC). Here, select Open in Full Screen Mode.

1

Password protection

You can add a password to protect your document.

1 To do so, in the Properties window, click on the Security button at the top. In the drop-down Security Method menu, select Password Security. In the Password menu, alter your settings to suit the security level you want.

1

Print security

You can also control the print settings of your document so that an untrusted recipient cannot print the artwork.

1 Go to the Password Security window and tick Restrict Editing and Printing.

1

Watermark

To protect your work further, you can add a watermark.

1 To do so, go to Menu > Document > Watermark > Add. Edit the settings in the Add Watermark window. You can type in text or browse for an image to use as a watermark. Note that if you are using one of your own images as a watermark, it must be a PDF, JPEG or .ai file, not a Photoshop file. Edit the size, colour, angle and position of your watermark so that it covers as much of your work as you want. Then set the opacity to make the watermark as discreet as possible to avoid disturbing the overall view of your work.

2 To edit your watermark further after having placed it, go to Menu > Document > Watermark > Update.

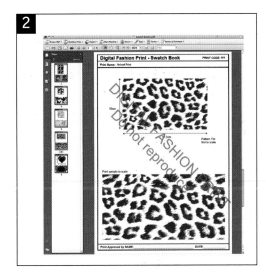

File size

Sometimes, even when you set the file size as small when creating the PDF, you might still need to reduce the file size further because, for example, it is too big to email. Usually 5MB is a good size for files to be emailed as this won't clog up your recipient's inbox.

1 To check the file size, go to Menu > Advanced > PDF Optimizer. To reduce the size of your PDF, go to Image, where you can adjust the compression and quality of the images; don't go too low, though, or the quality of the print might deteriorate too much. You can also select Discard Objects and make sure that all the boxes are ticked. Do the same for Discard User Data. Press OK and save the files with a new name. Do not delete the original larger file as you may need to make changes to it.

Combine files

You might need to add more pages to your PDF swatch book.

1 Open your 'unoptimized' document and go to Menu > File > Combine Files. Select the new pages you wish to add to the document and follow step 2 again (in the Making a PDF tutorial, page 164). Rearrange the pages as in step 4. Remember to add a watermark to your new pages, and change the initial view and security settings again.

Tutorial 18

Print technical packs

Illustrator

For most of us mere mortals, delivering technical packs to print houses, developers or manufacturers is a compulsory part of the design development process. A seasoned fashion print designer will be able to communicate clearly on paper (well, in PDF format rather) exactly how he or she intends to print their artwork on textile. Each designer or company has their own way of conveying and laying out information about a print in a technical pack. The most important point here is knowing what kind of information is required to ensure the smooth development of a print.

The main items needed in a technical pack are:
- 1:1 scaled version of the print.
- For all-over print, the print tile with measurements.
- A full description of the print technique.
- A full listing of print colours (unless it is a digital print).
- A clear indication of what fabric the artwork will be printed on.
- If possible, print samples showing the quality you want to achieve.
- For placement prints, a visualization of the print on the garment, with measurements.
- Each colourway (SKU) of the garment to be printed, with each print colour listed.

1 If you use Illustrator CS4 or CS5, create a new document in A4 or A3 size and select the number of artboards you require. For older versions of Illustrator, make the artboard big enough to accommodate the number of pages you need (for three A4 portrait pages, make the artboard 297 mm in height and 620 mm in width). Go to Print (⌘ + P or Ctrl + P for Windows PC) and under Options, click Tile; then go to Menu > Window > View Print Tiling.

2 Create a grid template for your technical pack; this will be repeated on each page. You should include important information such as company name, season, collection name, designer name and print style number.

3 Place your template on each of the pages, altering the page number for each, and lock the layer.

4 The first page should show your full repeated print as large as possible to give the manufacturer or printer an idea of the final outcome. If the print is not to scale, make sure that you mention this clearly.

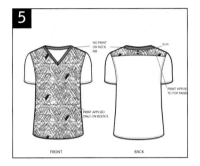

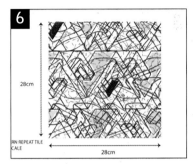

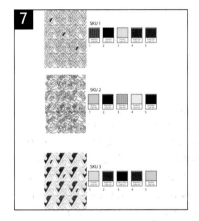

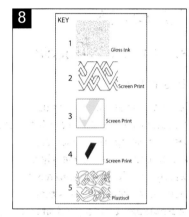

5 For better communication, it is a good idea to place the print on a working drawing of the garment, labelling relevant information. You can also give the measurements of relevant print sections.

6 If you do an all-over print, make sure that you include the print tile. This should come with measurements and, if possible, be to scale.

7 For the different SKUs, include a small sample of the different-coloured prints alongside colour swatches. These are usually named and are accompanied by a Pantone TPX colour reference or a company colour code. In the example here I have added a key number to each layer of the print.

8 Each key should explain in detail how each colour is to be printed and with which technique. Note that a digital print would not have different layers, as it will be printed as a flat image.

9 When you have finished your technical pack, save it as a PDF file and either select Multiple Pages in the Save dialog box (CS3 and below) or simply tick on All in the Save As dialog box (CS4 and above).

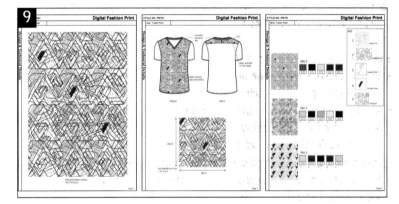

■ Quick tips

- You should always send the original artwork in either Photoshop, with a layer per print colour, or in Illustrator format, with the placement artwork or the original print tile. Some smaller print houses might not have Illustrator, in which case, send a high-resolution PDF file.

- Generally, it is always best to communicate with your developer or print house to make sure that you deliver the relevant files, dpi size and formats.

Tutorial 19

Preparing for print

Photoshop
Illustrator

Even though print preparation is the last stage in the print development workflow, designers should consider carefully at the beginning of their task, and with their print house, which print technology will be employed and which fabric the print will go on (as already explained on pages 12–13). This tutorial consists of a set of quick instructions on how to prepare your files for sending to the print house, depending on the application you are working with and the type of print you are developing.

Preparing a print in Photoshop

1 Unless your print is going to be printed digitally, you should have each colour of the print placed on a separate layer as this will help the print house to prepare the different printing plates.

2 Check with your developer or print house what dpi resolution is required for a specific print technique.

3 To avoid confusion, always ensure that each colour displayed in each layer has the correct code number corresponding to the colour codes in your technical pack.

4 As outlined in the section on trapping and knockouts, make sure that you trap the lighter colours to prevent gaps (select the layer content, go to Menu > Select > Modify > Expand, and expand by a few pixels).

5 Ensure that the layer order has the lightest colour at the bottom and the darkest at the top.

6 Depending on the ink, the fabric and the print technique used, you might need to have at the very bottom layer a white fill that covers the entire artwork; however, make sure that the colour is never full white but a light grey to enable printing plates to be produced.

Preparing a digital print

When working on designs that will be digitally printed, it is important to consider the following points:

1 Digital print is basically inkjet print technology on textile support. The fabric base is always white (like paper), so you cannot print white.

2 Avoid using big areas with solid colours (the technology is still not perfect), which can result in low yield in bulk production.

3 Always make a proof print, using a good-quality inkjet printer, to check print quality, especially if you have been compositing images from different sources. This is because digital printing is high resolution and therefore unforgiving of sloppy compositing!

4 Digital print cannot be an all-over print, so you must consider the positioning of the print in relation to the different garment pieces on which it will be printed. Avoid focal points, which tend to unbalance the print and are easy to spot.

5 Try to balance the print equally on the left and right side and mark the centre front (or centre back) of the print panel to ensure easy positioning for bulk production.

6 Always request a print strike and colour strike to ensure that the colours are accurate.

Preparing a print with trapping and knockouts in Illustrator

Fabric, unlike paper, stretches and has a more textured surface. Trapping helps to prevent the gaps between colours that can occur when the print registration is off due to stretched or uneven surfaces. Knockout helps to keep ink density low by removing fully overlapping colours. The illustrations below and right clearly show the difference between knockouts and trapping.

A two-colour artwork

The same artwork in 3-D view with fully overlapping background colour

The same artwork in 3-D view with a knocked out background colour

The same artwork in 3-D view with trapped background colour (note how the colour overlaps the black colour)

Other issues to consider:

1 Use Pathfinder Divide to create knockouts and Outline Stroke to create trappings.

2 Make sure that you transform each colour used in the print as spot colours.

3 Ensure that no colour other than the one used for your print is present in your file (in the Swatches palette, go to Menu > Select All Unused Colour and then click on the bin icon).

Glossary

Computer technical terms

Bitmap A digital image made of pixels displayed in a grid. Each pixel contains singular colour information.

CCD chip (Charge-coupled device) A chip consisting of thousands of pixel elements, which captures light and transfers the information to the camera processor.

DPI (Dot Per Inch) The resolution of a bitmap image is defined by its DPI measure. The higher the DPI, the better the quality.

EPS (Encapsulated PostScript) File format for importing and exporting PostScript files.

GUI Graphical user interface.

Non-destructive editing Digital-based editing that allows the user to alter content without destroying the original material.

Pixelated Low-resolution images within which pixels are visible, usually creating jagged edges within the image.

Plug-in (also Plugin) A piece of software that adds extra abilities to compatible applications.

PostScript A page-description programming language commonly used in the desktop publishing sector.

RAM (Random Access Memory) The live memory that your computer needs to temporarily store data for its chip to access and process.

Raster graphics Digital data in the form of a grid of pixels, representing an image.

RIP (Raster Image Processor) A hardware or software component used in a printer (usually a laser network printer), which produces a raster image.

Scripting End-user software language within applications that allows the customization and extension of the available functionality.

UI user interface.

Vector graphics Digital graphics based on mathematical equations, such as Bézier curves, made up of points and segments.

WYSIWYG 'What you see is what you get'. Computing term describing a system in which what is displayed on screen appears exactly the same as the final output.

Adobe terminology and features

Beautiful Stroke In Illustrator CS5, a set of functions that enable high customization and enhancement of strokes.

Bézier curves An editable curve used in computer graphics, invented by the French engineer Pierre Bézier.

Bristle Brush Brushes used in both Illustrator and Photoshop that mimic 'real-life' brushes.

Embedded Images In Illustrator, embedded images are embedded into the document without any link. Embedded images do increase significantly the Illustrator document file size. See also Placed Images.

Smart Filter Any filter applied to a Photoshop Smart Object.

Smart Objects Layers in Photoshop containing images with all their original data, enabling nondestructive editing.

Perspective Drawing In Illustrator CS5, a feature that enables users to draw and render artwork in perspective.

Placed Images In Illustrator, placed images are dynamically linked from their folder location into the document. If they are removed from their folder, the link is lost. See also Embedded Images.

Vignette photographic term describing an elliptical zone around the edges of an image that is darker than the centre of the image.

Print, design and fashion technical terms

AoP (All over Print) Print that covers the entire surface of a fabric roll.

Amberlith masking film A transparent orange substance applied onto a clear acetate sheet, which photographs as opaque so it can be used to block out areas that should not be printed. Amberlith has been superseded by transparency film or waterfast inkjet film.

Calender A series of hard-pressure rollers to transfer print onto textile. Usually a calender used in textile print is hot, to fuse the print onto the cloth.

Compositing or 'comping' The process of combining several images into one to create a new image.

Curing The process of fixing certain inks such as Plastisol using a flash dryer. Most inks need to reach a temperature of about 160°C for full curing.

DTG (Direct to Garment Printing) A reference to digital print, as the process from computer to garment is direct (no need for a transitional stage, as in other print methods).

FoB (Freight on Board) A term used in shipping, included within a garment factory's price per unit and denoting that the goods will be supplied ready to be freighted.

Garment dyeing A technique in which finished garments (usually made of ecru cotton) are dyed in small batches (of usually up to 1000 pieces). A highly flexible way to dye garments in small quantities, with quick 'just in time' response to market needs.

Houndstooth Duotone textile with a broken check pattern, which originated in Scottish wool cloth.

Knock out To delete overlapping print surfaces to avoid layering of ink.

Mélange Wool fabric made from spun mélange yarn. It is distinguished by its unique variegated colour effect.

Mimaki printer The market-leading large-format digital textile printer.

MoQ (Minimum order quantity) Minimum quantity of apparel or length of fabric that must be ordered to get goods produced in bulk.

Piece-dying A technique in which a piece (or roll) of woven or jersey fabric is dyed after weaving.

Pinstripe Narrow white stripe on a dark base, usually used in men's woollen suiting fabric.

Print Registration Method employed using registration marks in a multiple-colour print to accurately correlate each colour between different printing plates.

Print strike A first print done by the print house, to test quality, surface, colours and artwork.

Print tile A rectangle (or square) containing artwork, which defines the area and boundaries of a repeat pattern.

SKU (Stock-keeping units) An identifying code for each style and colourway designed.

Squeegee A wooden tool used in screen printing, with a flat, smooth rubber blade to spread ink evenly.

Transparency film Transparent film substrate on which black areas represent areas not to be printed.

Trapping A thin, overlapping print surface between colours, created to avoid gaps in print artwork.

Yarn dyeing A technique in which individual yarn is dyed before it is woven or knitted. In comparison with garment-dyeing and piece-dyeing, yarn-dyeing provides fuller and longer-lasting colour.

Pantone TPX or TC In the Pantone colour company's code for fashion and interior colour ranges, TPX indicates a colour that is printed on paper, while TC refers to dyed cotton.

Printing methods and techniques

Here is a very short introduction to the print technique types that are most commonly used in the fashion industry. This list is not exhaustive and only contains techniques that are commonly found.

Traditional methods

Calico printing Imprinting on cotton calico textile using colourfast ink.

Hand block printing Printing on textile using ink-covered carved wooden blocks.

Stencil printing Printing onto textile using card stencils with cut-out areas onto which ink is applied.

Modern methods

Screen printing (also known as serigraphy) The process of spreading ink with a squeegee onto fabric through a thin woven mesh with screened and open areas (the artwork).

Rotary screen printing Industrial and highly productive screen-printing method where each colour composing an artwork is printed from a different screen, which rotates and positions itself accurately on the fabric to be printed.

Roller printing A technique in which dye paste is applied to cloth using metal rollers, which span across the fabric width and are engraved with a print design. Each colour requires a separate roller.

Transfer printing A two-step process, starting with printing an
artwork on paper with special dyes. The artwork is then fused to
textile using high heat with a hot press or a calender (see above).

Digital textile printing Printing on textiles and garments using
specialized inkjet technology.

Printing techniques and inks

Most of the techniques below are only relevant for screen printing, as
digital printing and roller printing require more limited ink types.

Plastisol Very opaque ink, with a flexible, raised, plasticized texture,
which requires heat to cure.

Water print Penetrative ink, which creates a soft, textural feel. In
this technique it is best to print darker inks onto light-coloured
cloth.

Discharge A technique used to print lighter colour onto dark fabric
by removing the fabric dye.

Flocking glue printed onto fabric with flock material applied,
resulting in a velvety touch.

Raised flocking similar to flocking, with a raised profile added.

Glitter Ink mixed with metallic flakes to create a sparkling effect.

Metallic ink Ink mixed with fine metal particles to create a
metallic effect.

Puff or expanding An ink additive that raises the print for an
embossed effect.

Four-colour process (CMYK) This process is used to replicate all
the colours of the spectrum with four basic ink colours: cyan,
magenta, yellow and black. A white background is needed to
achieve vibrant colours.

Gloss shiny-finish print.

Nylobond An additive that is mixed with Plastisol inks to provide
adhesion to waterproofed nylon fabrics.

Foil Metallic foil heat-pressed or stamped onto Plastisol ink.

Burn out Burning away the polyester in a poly/cotton mix fabric,
resulting in sheer and subtle print patterns.

Contributors

Atelier 4 à 4
Sandra Boursin and Muriel Douru
atelier4a4@yahoo.fr
www.atelier4a4.com

Carol Bailey
+44 (0) 7845642739

Nicholas Thomas Biela
nicholas_biela@hotmail.co.uk

Jean-Pierre Braganza
studio@jeanpierrebraganza.com
www.jeanpierrebraganza.com

Michael Brimmer
michael.brimmer@bensherman.
 co.uk

Claudia Caviezel
cc@caviezel.cc
www.caviezel.cc

Jacqueline Colley
jacquelinecolley@hotmail.co.uk
www.jacquelinecolleyhome.
 blogspot.com

Trevor Dickinson
www.trevordickinson.com

Cathryn Eardley
cathryn.eardley@btinternet.com
www.cathryneardley.blogspot.
 com

Danielle Hensby
dnhensby@btinternet.com

Joseph Hodgkinson
Without Backbones
joseph@withoutbackbones.com
www.withoutbackbones.com

Jellymon
www.jellymon.com

Chae Young Kim
chaey.kim@yahoo.co.uk
www.chaeyoungkim.com

Oberon Kok
Oberon@home-made.nl
www.home-made.nl

Mudpie Ltd
www.mudpie.co.uk
www.mpdclick.com

Tina Munther
tina.munther@hotmail.com
www.coroflot.com/tina_m

Mario Schellingerhout
0031624921160
Mario@nothingfancy.nl
www.nothingfancy.nl

Alicia Mary Seal
aliciaseal@hotmail.com

Helen Semple
+44 (0) 7830 444299
helensemple@gmail.com

Changbae Seo
changbaeseo@gmail.com
changbaeseo.com/

Niamh Smith
Niamhsmith@littleredtreacle
www.littleredtreacle.com

Howard Tangye
howardtangye@yahoo.co.uk
howardtangye.com

Andrew Todd
and_todd@yahoo.co.uk

Ying Wu
eveangelawy@gmail.com
ying.wu@network.rca.ac.uk
www.alotofpatterns.com

Index